PENGUIN BOOKS

How to Draw the Human Figure

Louise Gordon is a graduate of Toronto Teachers' College, of Queen's University, Kingston, Ontario, and of the University of Toronto, where she qualified in the three-year course of Art as Applied to Medicine. A member of the Canadian Academy of Medical Illustrators, she was lecturer and a member of the staff at the University of Toronto for eight years and in addition was staff artist at Sunnybrook Veterans' Hospital. For some years she worked as a free-lance artist on several of the leading medical textbooks in anatomy, surgery, and histology. For the past ten years Louise Gordon has been working in fine art and as a part-time teacher. Until recently she taught Anatomy and Life Drawing at the Sir John Cass College of Art, London. She is also the author of *How to Draw the Human Head: Techniques and Anatomy*, also published by Penguin Books.

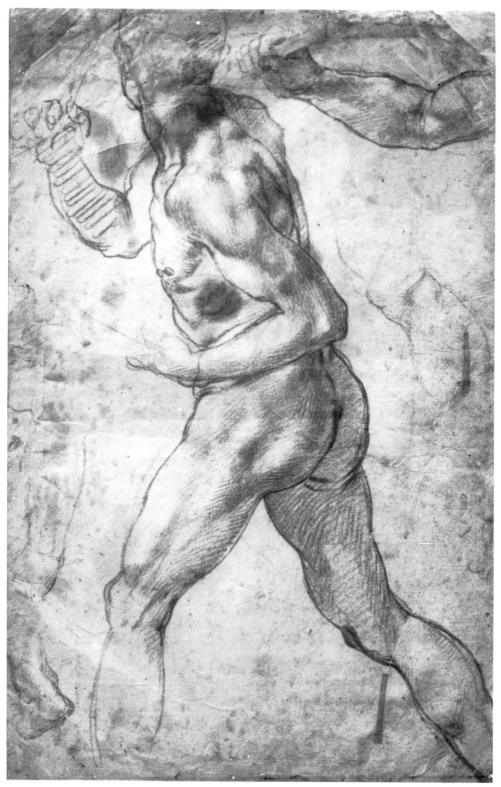

Study of a Nude by Michelangelo
Teylers Museum, Haarlem

How to Draw the Human Figure

An Anatomical Approach

Louise Gordon

Penguin Books

To Andrew

PENGUIN BOOKS
Published by the Penguin Group
Penguin Group (USA) Inc.,
375 Hudson Street, New York, New York 10014, U.S.A.
Penguin Group (Canada),
90 Eglinton Avenue East, Suite 700, Toronto, Ontario, Canada M4P 2Y3
(a division of Pearson Penguin Canada Inc.)
Penguin Books Ltd,
80 Strand, London WC2R 0RL, England
Penguin Ireland,
25 St Stephen's Green, Dublin 2, Ireland
(a division of Penguin Books Ltd)
Penguin Group (Australia),
250 Camberwell Road, Camberwell, Victoria 3124, Australia
(a division of Pearson Australia Group Pty Ltd)
Penguin Books India Pvt Ltd,
11 Community Centre, Panchsheel Park, New Delhi - 110 017, India
Penguin Group (NZ),
cnr Airborne and Rosedale Roads, Albany, Auckland 1310, New Zealand
(a division of Pearson New Zealand Ltd)
Penguin Books (South Africa) (Pty) Ltd,
24 Sturdee Avenue, Rosebank, Johannesburg 2196, South Africa

Penguin Books Ltd, Registered Offices:
80 Strand, London WC2R 0RL, England

First published in the United States of America by
The Viking Press (A Studio Book) 1979
Published in Penguin Books 1980

20 19 18 17

Printed in Singapore by Kyodo Printing Co. Ltd

Contents

Acknowledgment

My thanks are extended to the publishers and especially to Thelma M Nye and also to Andrew Cooper for his ideas and constant encouragement. I would also like to express my gratitude to five teachers: Elwood O Simpson, Maria T Wishart who started the Art as Applied to Medicine course in Canada and encouraged me as a student and friend, Dr JCB Grant, Professor of Anatomy and Dr AW Ham, Professor of Histology with whom I was fortunate to be a student in their courses at the University of Toronto, and Fred Hagan, Ontario College of Art.

Louise Gordon
1979

Preface

The act of drawing is the miraculous act of illusion, the creation of an emerging form by the inference of light through dark, on a blank surface. For those desiring to create the form of a figure whether for a finished drawing, preliminary sketches for sculpturing, or underlying structure in painting, the path of development is much the same if the appreciation of fine draughtsmanship is present.

Many different kinds of line have been used by artists which reveal in a very personal way their feelings and thoughts of what they have seen and experienced. There is the continuous committed line which can be precise or loose in containing form, and light or heavy. There are short choppy lines, free tactile lines, wandering sinuous lines, and lines which within themselves vary from light to dark depending on the pencil or tool used. The information on the figure here provided is adaptable to any drawing technique.

This book is intended to help in understanding what you already see and should help you see more so that a greater intimacy and a greater freedom can be established. For those who are, or who desire to be more deeply involved, it contains the elements of growth. Interpretation is of course a private matter between you and the blank page. Anatomical knowledge can be used for selective emphasis, for subtlety and strength, for playfulness and whimsy, and for realism.

As much as possible the anatomical information is unified with the forms visible on the surface by placing them on the same page, the facing pages, or by integrating the two in the drawings. Particular attention is focused on bone structure from different aspects as it provides so many constant points of reference. The head is considered in this book mainly as part of the whole figure unit. More detailed anatomical information and drawing techniques are contained in my previous book, *Drawing the Human Head*, also published by Batsford.

Putney Heath, London 1979 LG

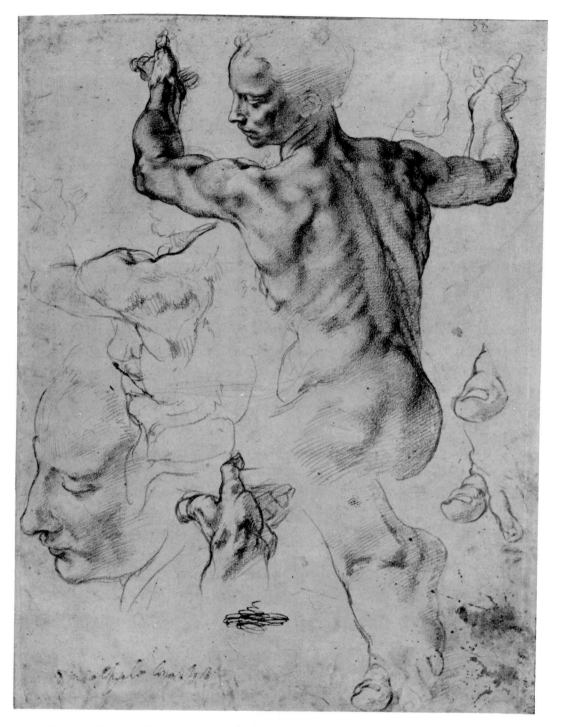

Studies for The Libyan Sibyl *by Michelangelo*
Red chalk on paper
The Metropolitan Museum of Art
Purchase 1924, Joseph Pulitzer Bequest

The skeleton

The skeleton is comprised of bones which are living things supplied by blood and nerves. They can become weaker and thinner with disuse, or heavier and stronger when they have increased weight to support over a period. They also change with transient illness and with malnutrition.

They begin in the embryo as tiny membranous or cartilaginous phantoms of what will be, soft and pliable, in which salts and a binding medium called cement substance are gradually laid down as enlargement proceeds. This process of ossification creates the hard bone which we know, and is usually not completed until the twenty-fifth year.

The skeleton is the framework of our bodies and the bones of it have specific functions which they perform. The long bones of the arms and legs act as levers for the muscles so that both strong and delicate movements are possible. The flat bones which form the vault of the skull protect the brain. The cage of ribs protects the heart, lung and liver. The basin formed by the flat bones of the pelvis not only protects the abdominal viscera to some extent, but bears their weight. The bones of the wrist and arch of the foot are many and small, bound tightly together by fibrous structures called ligaments so that the force from impacts on the hands and feet can be dissipated through this flexible little network, without a fracture occurring.

Where muscles and tendons are attached to bone so that they can create movement, outgrowths of bone can develop called tubercles, tuberosities and processes.

Although we each have approximately the same number of bones (two hundred and six), a few fuse together with age, and we can be born with extra or absent ones. But the main components of the skeleton are the same. We all have skulls, rib cages, and pelvises. However, these can vary greatly from person to person. A rib cage can be long and narrow, short and wide, rounded or flattened and all the variations of these features. The skeleton contributes to the 'build' of a person, regardless of the muscles and fat.

The information included on the skeleton, as on all parts of the body, is not to provide rules, but to give further knowledge of the forms and movement possible. Do not forget you have your own body to look at, to examine closely and to move. The landmarks of the skeleton will hopefully enable you to structure not only more soundly, but also with more affinity.

The skull

The skull creates the basic forms of the head and provides many surface landmarks with which to structure.

The bones of the CRANIUM are the housing for the brain. They are curved, thin plates which have separate centres of ossification in the embryo, and which eventually become hard bone rigidly locked together in the adult to make the almost enclosed vault. The cranium is responsible for much of the mass of the head form and this should be considered carefully when the proportions of the whole head are being assessed.

The slope of the FOREHEAD is dependent on the frontal bone, and its plane changes from the front to the sides of the head and to the top of the cranium. These plane changes can be felt with your finger tips and if there is one direct source of light falling on one plane, the rest will be in shadow.

The EYES lie protected in two cones of bone called the orbital cavities. These lie on the front plane of the face. The rims of these cones can be felt readily on your own face. They create a thrust which can be seen under the eyebrow and a definite movement below the area of soft tissue in the lower lid area.

The NOSE is constructed partly of bone and partly of pliable cartilages so the nostrils can be expanded. Where the nasal bones meet the cartilages just below the bridge of the nose there is often a plane change or bump. The bones can make a greater width on this nose at this join also.

The MANDIBLE (jaw) provides the only movable joint in the head. This joint is in front of the ear where the rounded process, the head of the mandible, fits into a socket on the cranium. Just behind this joint is a hole called the external auditory meatus, a canal leading into the middle and inner ear. It is around this that the external ear is structured. There is an outgrowth of bone behind the ear called the mastoid process from which the great sternomastoid muscle of the neck arises.

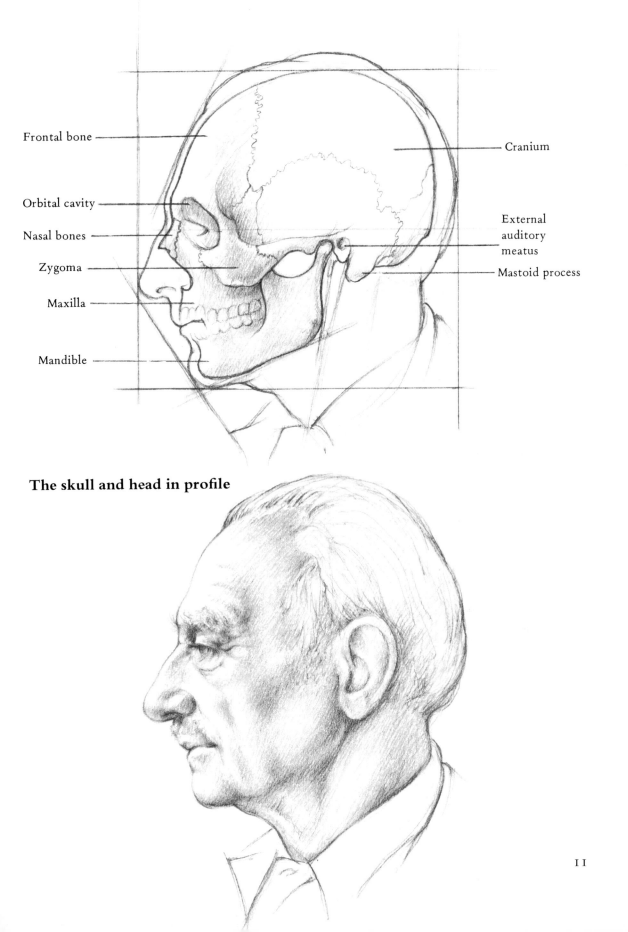

Frontal bone

Orbital cavity

Nasal bones

Zygoma

Maxilla

Mandible

Cranium

External
auditory
meatus

Mastoid process

The skull and head in profile

The bones of the trunk

The bones of the trunk consist of the rib cage strongly linked to the vertebral column which lies in the central axis. To this unit are added the pectoral girdle which consists of the clavicle and scapula, and the pelvic girdle which consists of the pelvis.

The VERTEBRAL COLUMN is made up ot thirty-three vertebrae. The first twenty-four of these are separate bones which are capable of movement because there is between each one a cushion or articular disc. The next five vertebrae are fused in the adult into a composite bone and are then called the sacrum. The last four fuse in middle life and are called the coccyx. The first vertebrae has a joint between it and the skull. The twenty-fourth vertebra has a disc between it and the sacrum.

The RIB CAGE is formed by twelve pairs of ribs each of which has joints with one or two vertebrae. The upper ten pairs are joined in front to the sternum (breast bone) by pliable cartilage (gristle). This arrangement allows the sternum to swing up and the chest to expand during respiration. The lower two pairs of ribs are not joined to the sternum and are called floating ribs (though they are held firmly by muscles).

The PECTORAL GIRDLE is made up of the clavicle which joins at the medial end with the sternum to make the sterno-clavicular joint, and the scapula which is joined to the lateral end of the clavicle to make the acromio-clavicular joint. The main function of the clavicle is to thrust the scapula back. The scapula has great freedom of movement to move up and down and rotate around the rib cage but it is controlled by the clavicle and ligaments.

The PELVIS is formed by the two hip bones which articulate with the vertebral column at the sacro-iliac joint. They meet in the median plane in front to make a joint called the pubic symphysis.

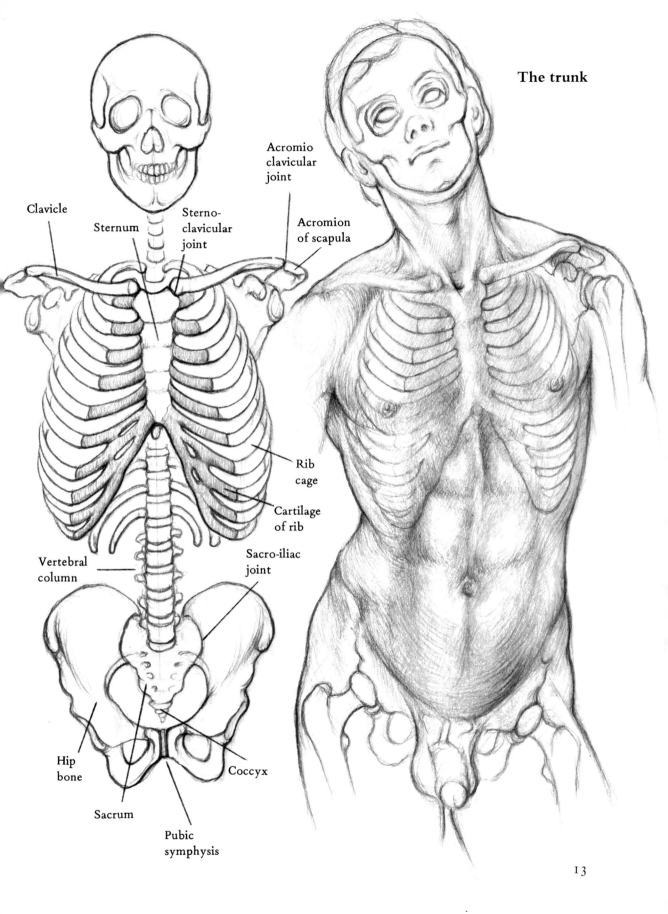

The trunk

Clavicle

Sterno-clavicular joint

Sternum

Acromio clavicular joint

Acromion of scapula

Rib cage

Cartilage of rib

Vertebral column

Sacro-iliac joint

Hip bone

Coccyx

Sacrum

Pubic symphysis

The rib cage or bony thorax

The thorax is that part of the trunk which is between the neck and the abdomen. The bony thorax includes the sternum (breast bone), the twelve pairs of ribs (costae) and their costal cartilages, and the twelve thoracic vertebrae. It protects the lungs and heart and the viscera (internal organs) between the neck and the abdomen.

The sternum
The STERNUM has three parts, the manubrium, the body and the xiphoid process. The manubrium is the upper heavier section with a thickened upper border. The sternal ends of the clavicles articulate with it to make the sterno-clavicular joints and altogether they form the suprasternal notch which is a most important landmark at the root of the neck. The body is composed of four sternebrae (separate centres of developing bone) which fuse in the adult. The horizontal ridges of these fusions can often be seen especially on a thin person. There is an angle created where the manubrium and the body meet, called the sternal angle of Louis which is very noticeable on some persons. This joint allows the body to swing upwards during respiration while the manubrium remains still. The xiphoid process is the small bone, variable in length, at the lower end of the sternum and lies within the muscle there. The sternum creates a firm but movable attachment for the upper ten pairs of ribs. The great pectoral muscles uniting the chest wall and the upper arms are also partly attached to it. In birds where the pectoral muscles are relatively so much greater for flying, the bone mass of the sternum is greater and develops into a large keel, to accommodate the muscle.

The ribs or costae
There are twelve pairs of RIBS all of which articulate at the back with the vertebral column. At the front the ribs have a cartilaginous portion which is joined to the sternum except for the lower two pairs. The cartilage being flexible allows movement of the sternum and ribs during respiration. The upper seven ribs are joined directly to the sternum by cartilage. The cartilages of the eighth, ninth and tenth ribs join with the cartilages above them. Those of the eleventh and twelfth ribs end in muscle. This costal margin and the exact angle of it are important structures for the artist. If a person contracts their abdominal muscles it stands out clearly. The 'free' edge can be felt by the finger tips starting in the area of the xiphoid in the midline and moving downward and laterally (to the side). The ribs increase in length from the first to the seventh, the seventh being the

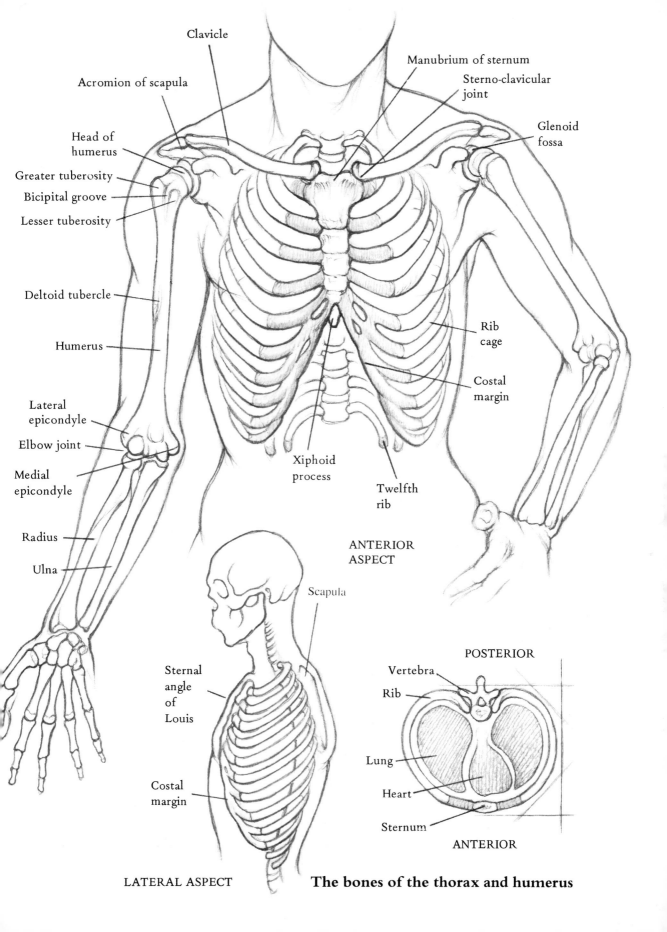

Clavicle

Acromion of scapula

Head of
humerus

Greater tuberosity

Bicipital groove

Lesser tuberosity

Deltoid tubercle

Humerus

Lateral
epicondyle

Elbow joint

Medial
epicondyle

Radius

Ulna

Manubrium of sternum

Sterno-clavicular
joint

Glenoid
fossa

Rib
cage

Costal
margin

Xiphoid
process

Twelfth
rib

ANTERIOR
ASPECT

Scapula

Sternal
angle
of
Louis

Costal
margin

POSTERIOR

Vertebra

Rib

Lung

Heart

Sternum

ANTERIOR

LATERAL ASPECT

The bones of the thorax and humerus

longest and having the longest cartilage. The greatest diameter across the bony thorax is at the level of the eighth rib. The ribs have a forward and downward angle from their vertebral joints, but the cartilages have an upward angle except for the upper and lower ribs. These forms can sometimes be seen. The head of the rib (the vertebral end) usually articulates with the bodies of two vertebrae and with a transverse process, which allows for the rib movement at the back.

All the ribs are joined together by the INTERNAL and EXTERNAL INTERCOSTAL MUSCLES which fill the spaces between the ribs. The muscle bundles of these two layers run diagonally to each other. They are muscles of respiration.

At birth the ribs are horizontal and the rib cage nearly circular in babies and young children. It is slightly more circular in the female than in the male. By the seventh year it is beginning to have an antero-posterior flattening with more definite front, sides and back and eventually becomes kidney-shaped in the adult. These subtle plane changes of the rib cage should be looked for on the thorax as it is through interpreting them that the volume of this most dominant part of the trunk can be expressed. There is a wide range in the size and forms of rib cages but the manubrium, sternum and the costal margins are constant landmarks from which to assess the width from the midline and the depth of a particular one.

The humerus

The humerus is discussed here because it completes the shoulder unit with the pectoral girdle which in turn is so intimately related to the bony thorax.

The HUMERUS is a long bone with a shaft, and two ends which articulate. The upper end has a rounded head covered by cartilage which is directed upward and slightly backward toward the glenoid fossa of the scapula with which it makes a joint. Because the head of the humerus is only one-third of a sphere and the socket of the scapula is shallow, great movement is possible at this joint. Next to the head lies the neck of the humerus to which the fibres of the capsule, which hold the head in the socket, are joined. Adjoining the neck are two projections of bone. The larger and more lateral one is called the greater tuberosity. It projects beyond the acromion, gives the shoulder its roundness, and can be felt on yourself through the deltoid muscle which covers it. The smaller projection of bone is called the lesser tuberosity. Between them lies a groove called the bicipital groove in which the long head of the biceps muscle lies in its tunnel. It is to these two tuberosities that the muscles of the scaupla attach by spanning the joint and are therefore able to rotate, lift and move back and forth the humerus. The shaft has a roughened area toward the front, not quite halfway down, into which the big muscle of the shoulder, the deltoid, is inserted. The lower end of the humerus is divided into two articular areas. One is round, called the capitulum (head), and fits into a shallow socket on the upper end of the radius. This allows both a hinge movement and rotation which will be discussed with the elbow joint. The second articular area is called a trochlea (spool-shaped) and makes a joint with the other bone of the lower arm, the ulna. Articular areas such as these on the ends of bones are called condyles, and are covered by cartilage which creates smooth surfaces within the joint and is insensitive. Just above these condyles the shaft widens into two projections called the medial (closer to the midline) and lateral epicondyles. The medial epicondyle can easily be felt on the inside of your elbow joint, lies just under the skin and makes a definite rather sharp form there.

The scapula

The SCAPULAE (shoulder blades) are triangular flat bones slightly arched from top to bottom to fit against the rib cage. They are situated on the back of the thorax in its upper part, and with the two clavicles form the pectoral girdles.

The superior (upper) angle reaches to the second rib. The inferior (lower) angle, which is strong and thickened bone due to muscle attachment, reaches usually to the level of the seventh rib. This inferior angle is an important form for the artist because the movement of it can be seen as the scapula changes position on the back. The lateral (to the side) angle consists of a shallow socket, the glenoid fossa, with which the head of the humerus articulates to make the shoulder joint.

Of the three borders of the triangular bone, the vertebral (medial) one which lies next to the central column of the vertebrae is the one which creates form for the artist to interpret.

There are two processes growing from this curved plate of bone. The spine of the scapula is a long diagonal process, raised off gradually from the back surface to end in a strong, thick free projection called the acromion. This acromion makes a hood over the humerus in its socket. It is a sturdy part of the spine as it withstands impacts from the humerus below and also the thrust of the clavicle against it at the acromio-clavicular joint. The acromion can be felt on your own shoulder when the arm is in a relaxed position. You can put your fingers around the tip of it, palpate the flat superior surface because it is subcutaneous (just under the skin) and follow the ridge of the spine across the back of the scapula, as it also is sub-cutaneous. The coracoid is a small stubby finger-like process projecting from the front of the scapula.

Both the ventral (front) and dorsal (back) surfaces of the scapula, its three borders, its three angles and its two processes provide bony surfaces for muscle attachment. The scapula is like a raft on the back which can be pulled in all directions by specially placed ropes.

The scapula is capable of movements up and down on the rib cage, backwards and forwards, and rotation forwards and up or backwards and down, all dependent on which muscles are contracting. It is this wide range of action which creates much of the changing form on the upper part of the back. Understanding the structure of the scapula and studying the positions into which it can be moved, bring a great integrity into even very subtle drawings of this region.

The scapulae vary in size and shape (short, long, wide, narrow) from person to person.

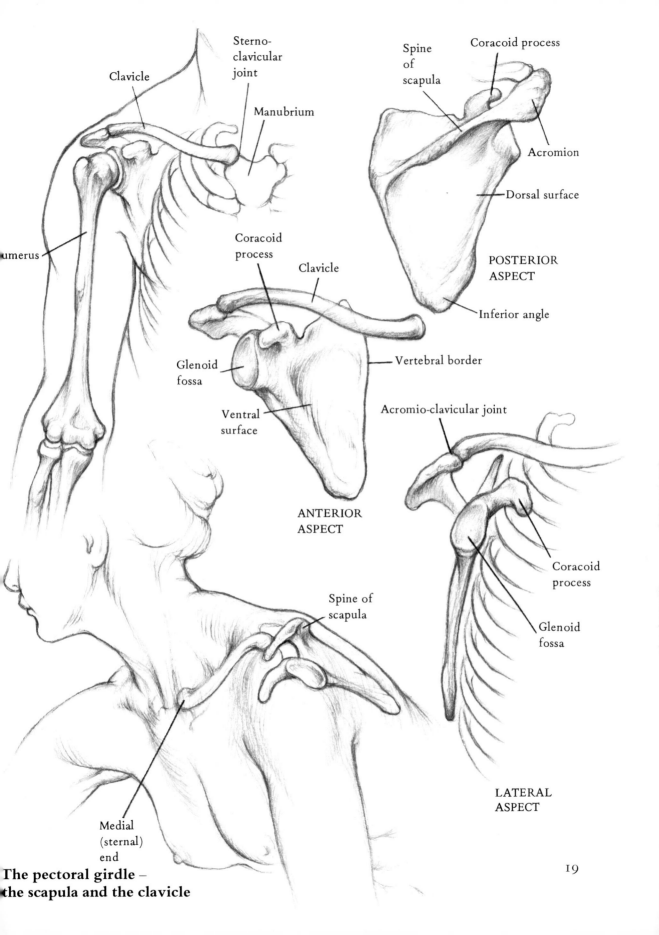

Clavicle

Sterno-
clavicular
joint

Manubrium

Spine
of
scapula

Coracoid process

Acromion

Dorsal surface

POSTERIOR
ASPECT

Inferior angle

umerus

Coracoid
process

Clavicle

Glenoid
fossa

Vertebral border

Ventral
surface

ANTERIOR
ASPECT

Acromio-clavicular joint

Coracoid
process

Glenoid
fossa

Spine of
scapula

LATERAL
ASPECT

Medial
(sternal)
end

**The pectoral girdle –
the scapula and the clavicle**

19

The scapulae The vertebral border and the inferior angle
of the scapula are lifted off the rib cage
The form of the root of the spine shows
The landmarks of the spines of the 7th
cervical vertebra and the 1st thoracic
vertebra are apparent

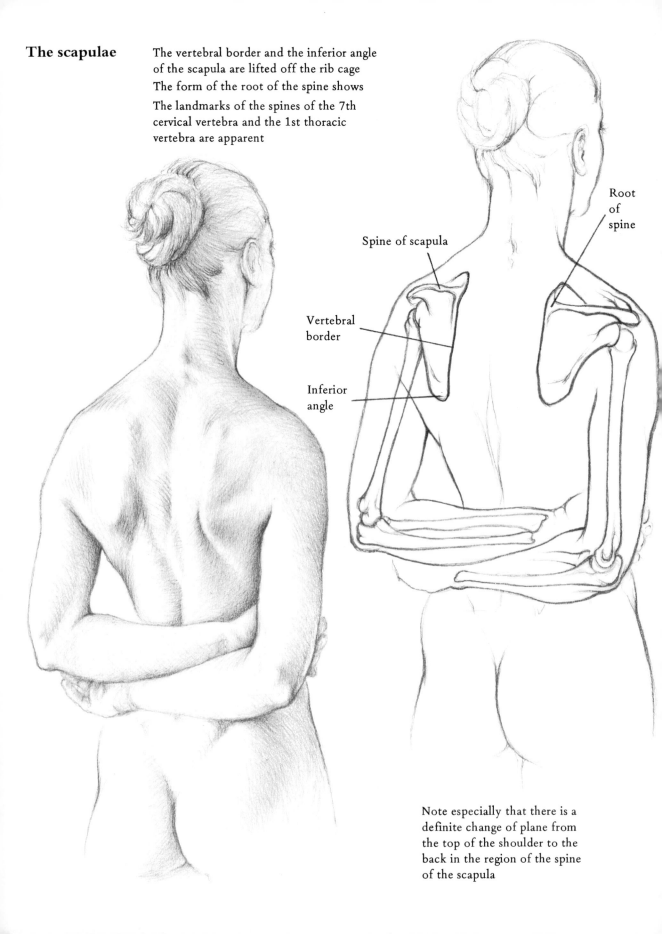

Spine of scapula

Root
of
spine

Vertebral
border

Inferior
angle

Note especially that there is a
definite change of plane from
the top of the shoulder to the
back in the region of the spine
of the scapula

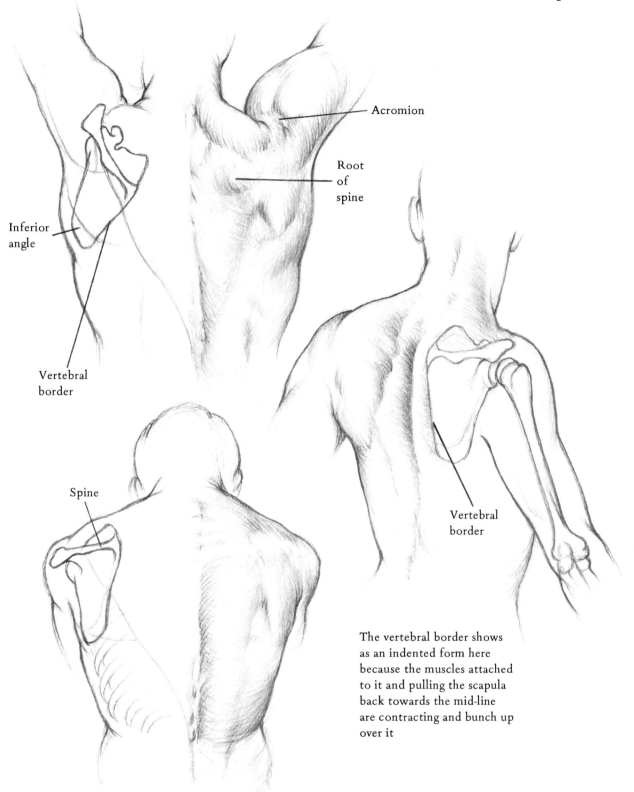

Acromion

Root
of
spine

Inferior
angle

Vertebral
border

Spine

Vertebral
border

The vertebral border shows
as an indented form here
because the muscles attached
to it and pulling the scapula
back towards the mid-line
are contracting and bunch up
over it

The clavicle

The two clavicles (collar-bones) are classed as long bones because they have shafts and two ends. With the two scapulae they form the two pectoral girdles.

A CLAVICLE is S-shaped with the medial part of the shaft curving forward and the lateral part curving backward. The medial two-thirds is round to triangular in cross-section with its sternal end enlarged. The two sternal ends make the sterno-clavicular joints with the manubrium of the sternum and appear often as 'knobs' at the root of the neck. The lateral one-third of the clavicle is flattened and its end makes the acromio-clavicular joint with the scapula. Because of the different forms of the shaft the two parts of it catch light differently.

In males the bone usually lies horizontally or with the lateral end raised. In the female the lateral end is usually lower. This lateral end moves up and down and backwards and forwards because of its joint with the scapula and is usually initiated by arm movement. These changes of position can be assessed on yourself in front of a mirror by placing the tips of the fingers of one hand on a clavicle and manipulating the arm on that side. The lateral end can often be seen as a bump on the upper surface of the shoulder where it is making the joint. Next to the bump and laterally will be the flattened upper surface of the acromion.

The clavicle holds the scapula back and out and provides surface for the attachment of neck, arm and chest muscles. It has a thin sheet of muscle over it, lying between it and the skin which allows the skin to move more freely during the shoulder movements. It can still be palpated from end to end.

The SUPRASTERNAL NOTCH is created by the two clavicles (collar-bones) meeting the manubrium (the upper part of the sternum or breast-bone) where they form the sterno-clavicular joints. It is an invaluable, stable landmark to use in measuring as it can always be seen. In this drawing which has the head slightly tilted and the trunk turned away, the distance from the notch to her left shoulder is the same as from the bottom of her chin to her brow. The distance from the notch to her right shoulder is the same as the bottom of her chin to her hair line.

Checking the measurements from the notch to the outer limits of the shoulders against an equal measurement of the head or face will always mean that you have them immediately in proportion.

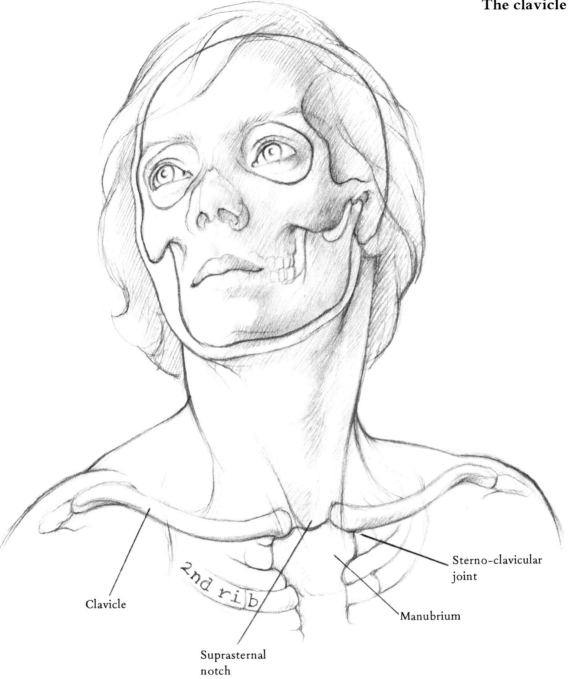

Clavicle

2nd rib

Suprasternal
notch

Sterno-clavicular
joint

Manubrium

The vertebral column and the vertebrae

The VERTEBRAL COLUMN is the central axis of the back of the trunk and in the adult it is made up of twenty-four separate vertebrae, five fused vertebrae called the sacrum and three to five coccygeal bones tail rudiments. The column is considered to have five regions: seven cervical vertebrae, twelve thoracic vertebrae, five lumbar vertebrae, the sacrum and coccyx. Except for the first two cervical vertebrae all the separate ones have cushions between them of a fibrous-gelatinous substance called the nucleus pulposus. This is surrounded by a fibrous capsule which binds two vertebrae together. These are called articular discs and act as shock absorbers as well as allowing movement to take place at each vertebral level. The fibres of the capsule are arranged in layers of diagonal fibres of opposite direction to aid mobility of the joint. Each vertabrae is weight supporting so they increase in size down to the fifth lumbar. At this point weight is transferred to the sacrum and then out through the hip bones to the legs if one is standing or to the two tuberosities of the pelvis on which one sits. The discs are relatively more generous in the cervical and lumbar areas so the column has a little greater freedom of movement in these areas (waist and neck).

The vertebrae of each region vary, and each vertebrae is different to some degree, but there is a common patterning. The weight bearing part is called the body and consists of a small cylindrical block of bone, 25 mm (1 in.) or less high and a little greater in width. It is covered on its upper and lower surfaces by cartilage where it is involved in the joint. From the back of this solid cylinder an arch of bone projects which creates a hole through which the spinal cord runs and in which it is protected. When the vertebrae are placed on top of each other the holes form a continuous canal from the skull so the spinal cord is protected from the moment it leaves the brain and skull. A transverse process projects from either side of this arch of bone and a spinous process from the back. These serve as levers for muscle attachment so the column can be bent. There are four articular processes on each vertebrae for joints with the vertebrae above and below. These are mainly to restrict movement and to prevent forward displacement of one vertebra on the next. They are so placed as to allow for rotation and in the thoracic region the movement between vertebrae is mainly that.

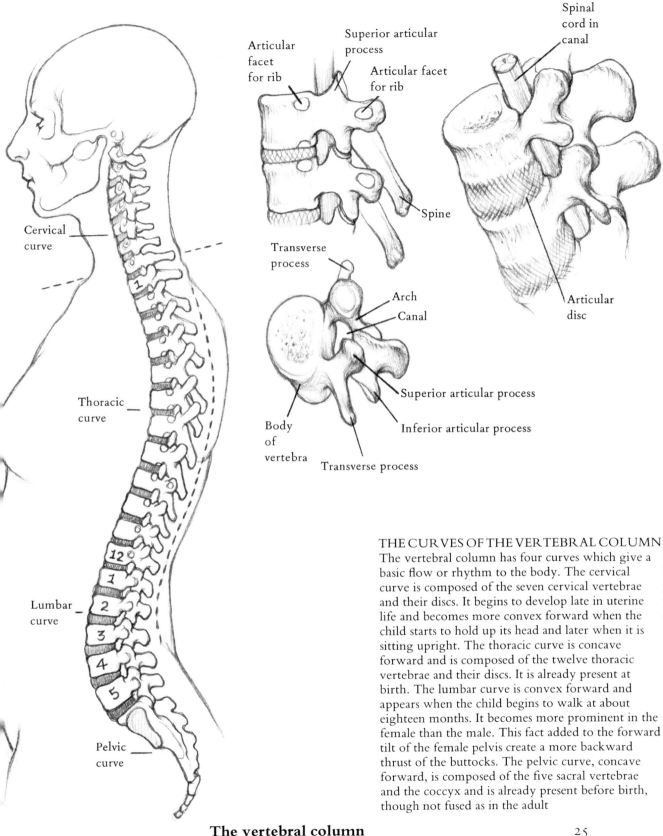

Cervical
curve

Thoracic
curve

Lumbar
curve

Pelvic
curve

Articular
facet
for rib

Superior articular
process

Articular facet
for rib

Spine

Spinal
cord in
canal

Transverse
process

Arch

Canal

Superior articular process

Body
of
vertebra

Transverse process

Inferior articular process

Articular
disc

THE CURVES OF THE VERTEBRAL COLUMN

The vertebral column has four curves which give a
basic flow or rhythm to the body. The cervical
curve is composed of the seven cervical vertebrae
and their discs. It begins to develop late in uterine
life and becomes more convex forward when the
child starts to hold up its head and later when it is
sitting upright. The thoracic curve is concave
forward and is composed of the twelve thoracic
vertebrae and their discs. It is already present at
birth. The lumbar curve is convex forward and
appears when the child begins to walk at about
eighteen months. It becomes more prominent in the
female than the male. This fact added to the forward
tilt of the female pelvis create a more backward
thrust of the buttocks. The pelvic curve, concave
forward, is composed of the five sacral vertebrae
and the coccyx and is already present before birth,
though not fused as in the adult

The vertebral column

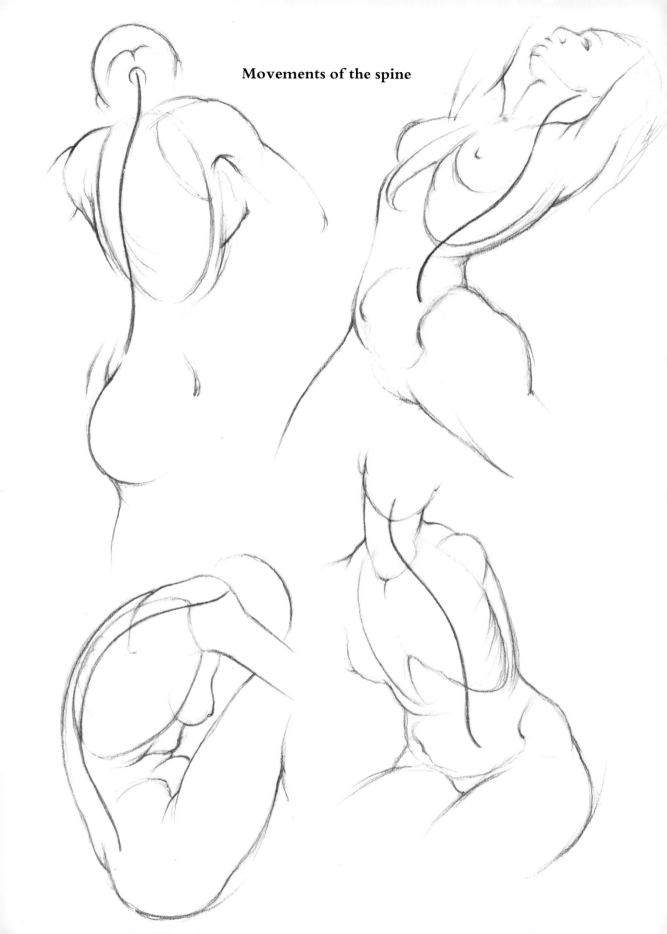

Movements of the spine

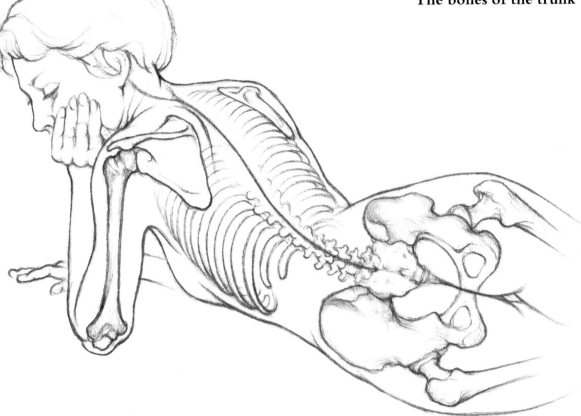

There are rotation or turning movements as well as the bending movements, and combinations of these

This shows the movement of the vertebral column which is both bending and rotating. The positions of the femurs making the two hip joints with the pelvic girdle and the humerus making the shoulder joint with the pectoral girdle are also shown. The femurs create the greatest width across the hips and the humerus projects beyond the acromion of the scapula

27

The pelvis

The PELVIC GIRDLE is composed of the two hip bones. These, with the addition of the sacrum and coccyx of the vertebral column, form the whole pelvis.

The two hip bones articulate behind with the sacrum making the two sacro-iliac joints. At the front they articulate the pubic symphysis. Both these joints allow limited movement.

Each hip bone consists of three parts: ilium, ischium and pubis. These three parts are fused by the sixteenth year and each contributes an element to the acetabulum which is the socket for the head of the femur. This is a deep socket in comparison with the socket for the head of the humerus.

The ILIUM is a large flat bone, rather fan-shaped, with a strong curved upper border called the iliac crest. At the front this crest ends in the anterior superior spine which has just below it a small projection of bone called the anterior inferior spine. At the back, the iliac crest ends in the posterior superior spine. The three structures, the iliac crest, and the two superior spines are exceptionally important landmarks for the lower part of the trunk. The crest is subcutaneous so it can be palpated easily unless a thick layer of fat intervenes. Its thrust can be seen on the surface. The anterior superior spines can be felt on either side, with your finger tips, and are very apparent on thin people and particularly on females where they project forward. In the male the spines are inturned which creates an indentation or a strong tuck on the surface.

The two PUBIC bones, the front of the hip bones, meet each other in the midline to make the pubic symphysis joint. The front surface of these bones give attachment to leg muscles.

The two ISCHII comprise the posterior and inferior parts of the hip bones. Part of them is made up of two heavy, roughened masses of bone called the right and left ischial tuberosities, on which one sits and which provide surfaces for the origins of muscles for the back of the thigh.

The pelvic girdle with sacrum and coccyx

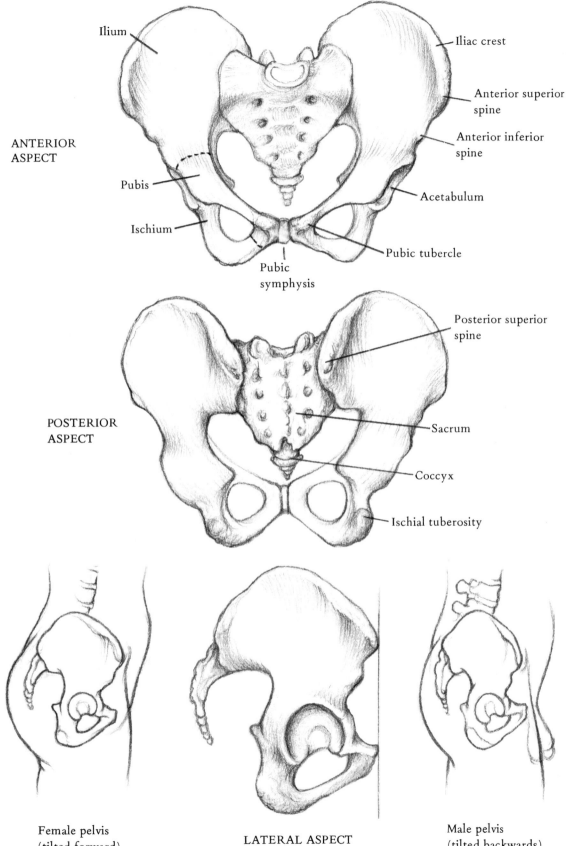

ANTERIOR
ASPECT

Ilium

Iliac crest

Anterior superior
spine

Anterior inferior
spine

Acetabulum

Pubis

Ischium

Pubic tubercle

Pubic
symphysis

POSTERIOR
ASPECT

Posterior superior
spine

Sacrum

Coccyx

Ischial tuberosity

Female pelvis
(tilted forward)

LATERAL ASPECT

Male pelvis
(tilted backwards)

Some differences between the female and male pelves

1 The acetabulum and therefore the hip joints are wider apart in the female.
2 The sacrum and coccyx are tipped up and back more which accentuates the hip movement in the female.
3 The basin created by the ilii is shallower in the female.
4 The distance between the anterior superior spines is slightly less in the female.
5 The anterior superior spines point forward in the female and are in-turned in the male.
6 From the position of the pelvis where the anterior superior spine and the pubic symphysis are on the same plane (see diagram), the female pelvis is tilted slightly forward and the male pelvis tilted backward. This also accentuates the backward hip movement in the female.

All female and male pelves do not fit these descriptions. A female can have a pelvis with male characteristics and vice versa.

A powerful one minute sketch capturing the gesture
and the solidity of the trunk unit. Brown conte on
cartridge by Ian Lawrence, Toronto, Canada

Bone landmarks on the posterior aspect of the trunk

The central axis of the vertebral column can always be seen. The form of the spine of the seventh cervical vertebra is usually apparent. The deep indentation in the lumbar area is where the lumbar vertebrae are curving forward and are more 'buried' by the longitudinal back muscles.

The form of the scapula can be seen. Look for the vertebral border, the inferior angle and the change of plane at the spine of the scapula. The acromion creates the most lateral point on the shoulder.

The big form of the whole thorax, which is caused by the rib cage, is the main structure.

The thrust of the iliums (the upper parts of the hip bones) with their iliac crests is seen in the hip area. The two 'dimples' are the posterior superior spines of the crests where tendons from the back and hip muscles are attaching to the bone, and the bone is close to the surface. The triangular area between them with its apex at the cleavage between the buttocks is the sacrum, covered by fibrous tendons and ligaments attaching to it.

The trunk

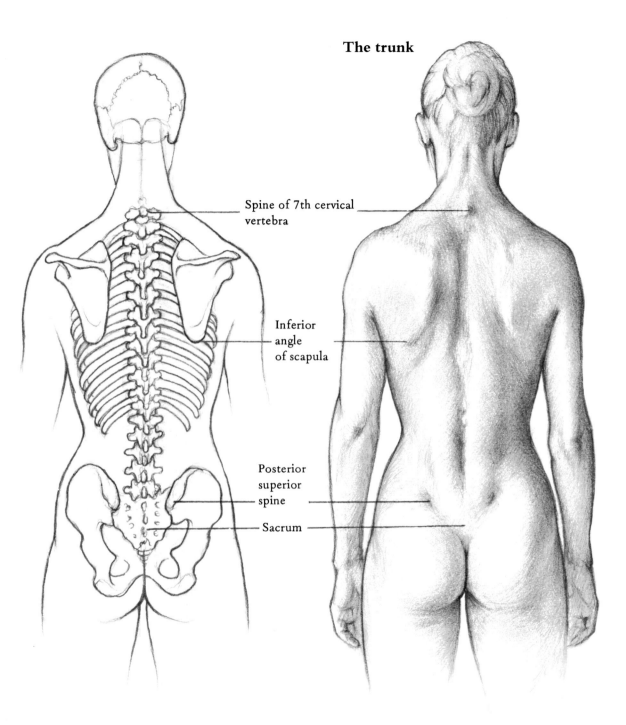

Spine of 7th cervical
vertebra

Inferior
angle
of scapula

Posterior
superior
spine

Sacrum

The bones of the trunk and neck

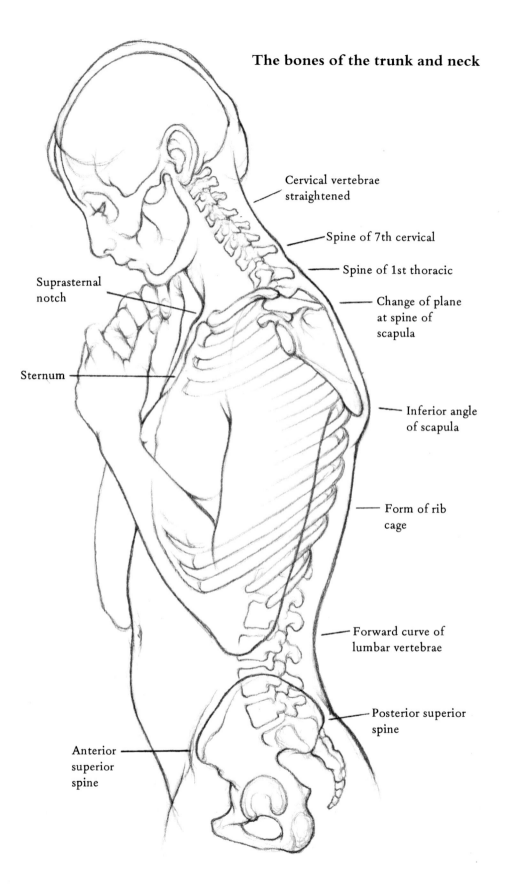

Cervical vertebrae
straightened

Spine of 7th cervical

Spine of 1st thoracic

Change of plane
at spine of
scapula

Inferior angle
of scapula

Form of rib
cage

Forward curve of
lumbar vertebrae

Posterior superior
spine

Suprasternal
notch

Sternum

Anterior
superior
spine

The bones of the trunk

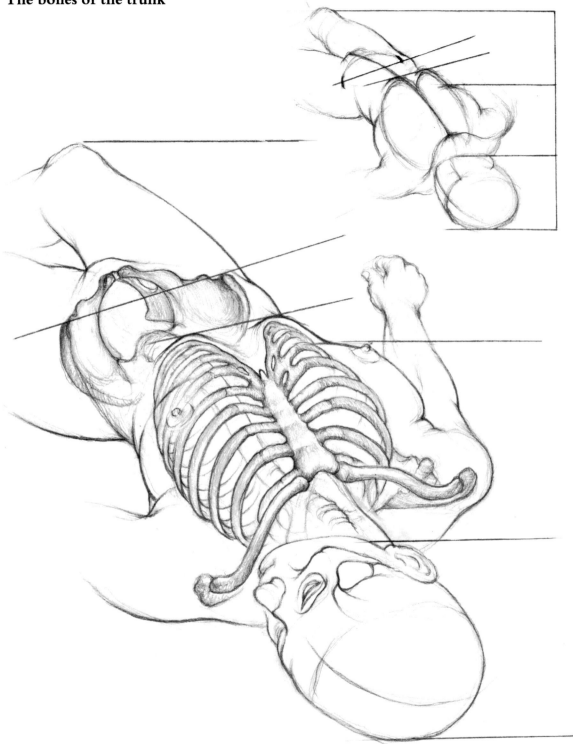

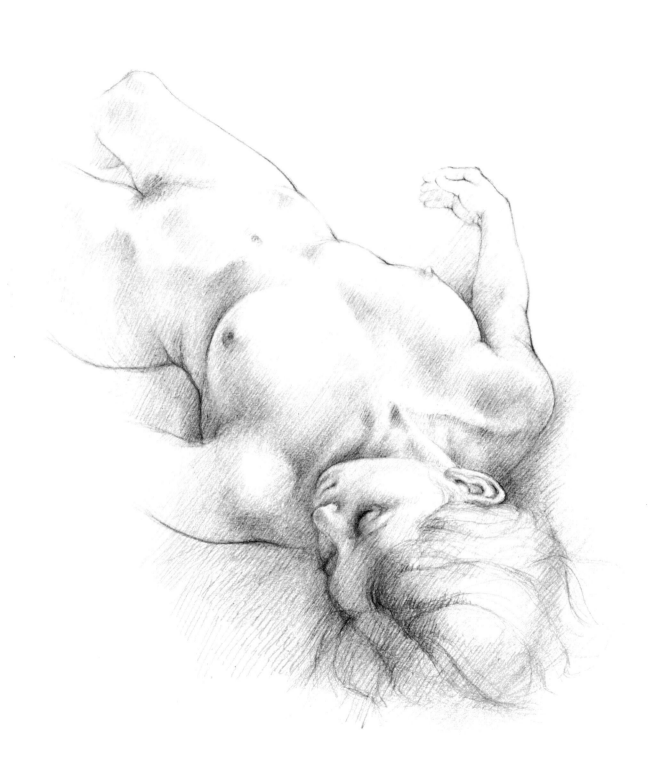

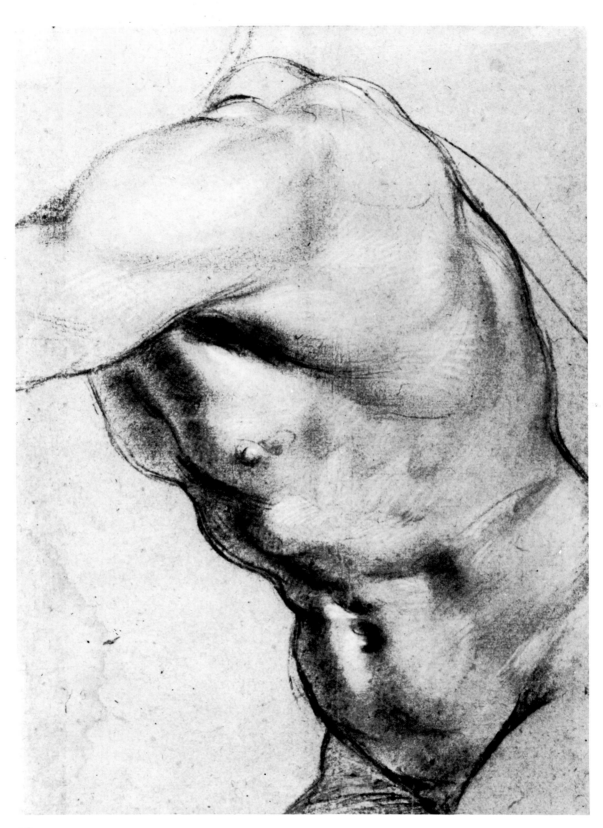

Muscles

The two components of a skeletal muscle are the fleshy part (meat) composed of the muscle cells and a fibrous part which is called a tendon or aponeurosis. Tendons are usually round and cord-like or flat and band-like. They are built for strength, consisting mainly of strong tensile protein fibres called collagen, which are arranged longitudinally in the muscle axis and are plaited. There are also present a low percentage of elastic fibres which allow for about 4 per cent contraction. It is now believed the tendons can store energy for the next muscle movement. When the tendon needs a wide area of attachment it assumes a sheet-like form and is then called an aponeurosis. The collagen fibres extend into the bone at their origins and insertions and it is this which results in the tubercles, tuberosities and processes, as extra bone growth is stimulated in this area. It therefore makes an exceedingly strong union.

MUSCLES throughout the body have different arrangements for their muscle bundles and tendons according to the largeness of the movement and the weight involved. The bundles of cells are arranged in long parallels if the action is to be sustained through a great distance, and in short diagonal bundles with far more numerous cells, if great power is needed through a short distance.

Annibale – Study from the Nude by Carracci
Royal Library, Windsor Castle. Reproduced by gracious permission of
Her Majesty Queen Elizabeth II

Muscles

Muscles act on our skeleton to move it. This is possible for two reasons: firstly, because a muscle is attached at both ends (from one bone to another, from bone to muscle, or from bone to skin) and secondly, because muscle cells are specialized to perform one function, and that is to contract. It is the contraction of bundles of cells comprising the fleshy part of the muscle which brings its two ends together, and so the two points to which it is attached.

Nature created muscle cells long and slender, some being up to 40 mm ($1\frac{1}{2}$ in.) in length, so that they can shorten. When they do so, they become plumper. They contain within their protoplasm tiny fibre-like structures called myofilaments (*myo*, Greek for muscle). It is thought that these myofilaments have charged sites along their lengths which make a potential attraction between them. When a nervous impulse is received, one myofilament slides along and lies against another to which it is attracted. This process of 'doubling up' occurs throughout the cell and it can shorten by approximately half. This is an extremely simplified explanation of the intricate mechanism of contraction. Thus a whole muscle which is composed of masses of these cells can contract by approximately half.

Each muscle cells is enclosed in a loose connective tissue which is a combination of fibres and cells imbedded in a jelly-like substance. These muscle cells line up end to end and side by side into bundles which are also surrounded by connective tissue. The whole group of bundles constituting the fleshy muscle belly are also covered by this tissue which is then called a muscle sheath. The cells are always free to contract and relax within this loose covering.

One end of a muscle attachment is always more fixed than the other end and is called the origin. When a muscle contracts, the other end, called the insertion, is pulled toward the more stationary point.

All the cells in one muscle do not have to contract at one time. If the work demanded of it is for a small movement, a small number of cells will perform. But there is an 'all or nothing' law for the cells. The cell itself must contract fully. When this happens with a group of cells in the muscle bundles the plumpness because of them shortening shows on the surface as a bulge under the skin. This also explains why a slow change of form can take place on the surface as more and more cells are brought into the contraction state.

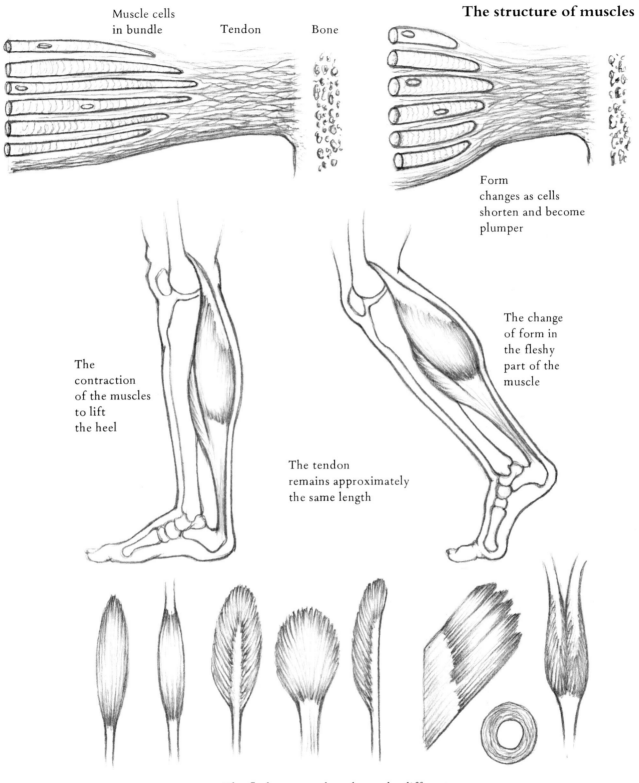

Muscle cells in bundle

Tendon

Bone

Form changes as cells shorten and become plumper

The contraction of the muscles to lift the heel

The change of form in the fleshy part of the muscle

The tendon remains approximately the same length

The fleshy part and tendons take different forms according to the attachment possible, the movement and power needed

41

The muscles of the face

There are two main muscles of the face which encircle the eye (Orbicularis Oculi) and the mouth (Orbicularis Oris). These two muscles are called sphincters because when they contract they close an opening.

ORBICULARIS OCULI fills the front of the orbital cavity and is attached to its rim of bone. Its muscle bundles also lie within the eyelids. Its form shows particularly under the eye.

ORBICULARIS ORIS has a free edge within the lips and within the cheeks. Several muscles of the face radiate into it and their muscle bundles blend. When these muscles contract they are therefore antagonistic to it as they pull it open. The richly curved form of it shows in all the upper lip area and is accentuated by the curve of the maxillae beneath it.

The FRONTALIS covers the frontal bone, its muscle bundles running vertically to blend with the orbicularis oculi at eyebrow level and with the aponeurosis which covers the cranium. When it contracts the skin of the forehead is thrown into horizontal folds and the eyebrows are raised.

The CORRUGATOR is a small cone-shaped muscle at the medial end of the eyebrow. It is attached to the frontal bone at its medial end and then its muscle bundles pass up through the frontalis muscle to attach to the skin. When it contracts it pulls the skin above the eyebrow toward the nose which causes puckering here. It is also responsible for the vertical creases in the skin of the forehead and at the top of the nose.

The MASSETER is the powerful muscle of the jaws which, by contracting, holds the lower jaw (mandible) tightly against the upper jaw and is used in chewing. It creates a rich curved form on the side of the face near the lower border of the ramus of the mandible, to which it is attached. Above, it is attached to the lower border of the zygomatic arch by a flat tendon.

The MENTALES are two cone-shaped muscles arising from the mandible mid-way between the lower lip and the bottom of the chin. The large ends of the cones are inserted into the skin of the chin. They raise the lower lip (pouting) and pucker the skin on the chin. The two little mounds of them are easily felt. If there is a dimple it is because the two cones are slightly separated.

The skull and muscles of the face

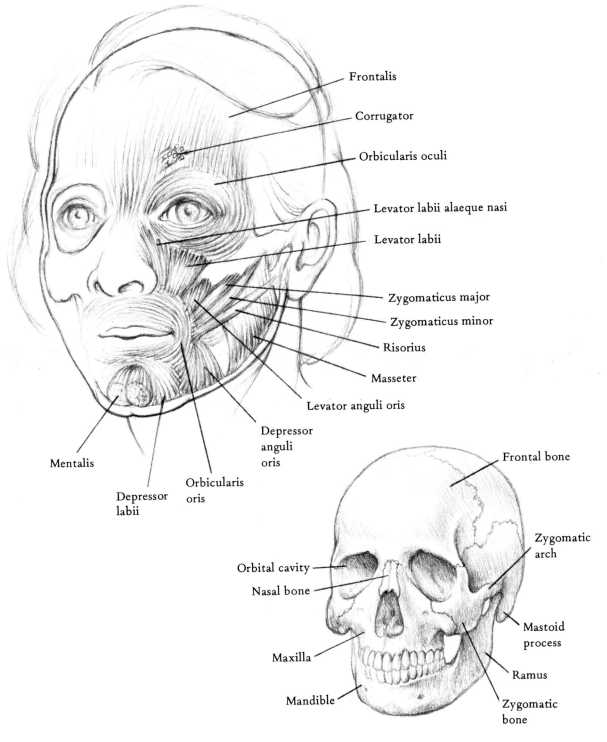

Frontalis

Corrugator

Orbicularis oculi

Levator labii alaeque nasi

Levator labii

Zygomaticus major

Zygomaticus minor

Risorius

Masseter

Levator anguli oris

Depressor anguli oris

Mentalis

Depressor labii

Orbicularis oris

Frontal bone

Zygomatic arch

Orbital cavity

Nasal bone

Mastoid process

Maxilla

Ramus

Mandible

Zygomatic bone

The muscles which are antagonistic to the orbicularis oris

The LEVATOR LABII ALAEQUE NASI (levator – lift, labiii – lip, alaeque – wing, nasi – nose) is a small muscle arising from the wing part of the maxilla close to the nasal bones and blending with the orbicularis which it acts on. It lifts the lip as its name says and can make the skin wrinkle on the side of the nose. It is responsible for that movement upward on the side of the nose.

The levator labii arises from the maxilla under the orbital cavity and inserts into the orbicularis oris. It shares the work of lifting the upper lip.

The LEVATOR ANGULI oris arises from the maxilla and inserts into the orbicularis oris at the corner of the mouth. It does what its name says, lifts the angle or corner of the mouth.

The ZYGOMATICUS MAJOR and MINOR arise from the zygomatic bone (cheek bone) and they both insert into the orbicularis oris near the corner of the mouth. They both lift and draw to the side the corner of the mouth and are called the smiling muscles.

The RISORIUS arises from the fibrous capsule of the parotid gland which overlies the masseter in front of the ear. Its muscle bundles insert into orbicularis oris at the corner of the mouth and when it contracts it pulls the corner almost horizontally. It is called the grinning muscle.

The DEPRESSOR LABII and the depressor anguli oris arise from the lower margin of the mandible and insert into orbicularis oris. The two labii meet and weave together in the midline above the mentales and cause a tightness of form there. Together, they create a flat form on the side of the chin. When they contract they pull down the lower lip and the corner of the mouth.

By placing your fingertips on the surface of your face over the sites of these muscles you can feel and see what they do.

The muscles which give the expressions of smiling, grinning and laughing

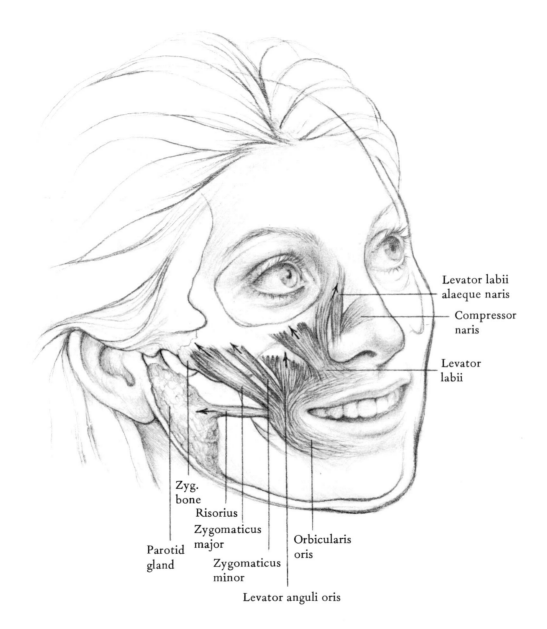

Levator labii
alaeque naris

Compressor
naris

Levator
labii

Zyg.
bone

Risorius

Zygomaticus
major

Orbicularis
oris

Parotid
gland

Zygomaticus
minor

Levator anguli oris

The basic structures of the neck

The basic forms of the neck include the column at the front, which can be palpated between your thumb and fingers, and which is composed of the air passage with its component parts, and the muscles which control it. The air passage is formed by the horseshoe shaped hyoid bone, the thyroid cartilage containing the vocal cords, the ring of cricoid cartilage, and the trachea (windpipe) with its incompleted rings of cartilage. These structures are all joined together to make a tube which is held open by the stiff but flexible cartilage. The thyroid cartilage is obvious on most necks of the male (the Adam's apple). This is because it is made up of two plates of cartilage which come together at the front and create an angle there. This angle is more acute (sharper) in the male than in the female. The column has a strong diagonal movement down and back because the trachea must pass behind the manubrium of the sternum where it then becomes the right and left bronchi to the lungs.

At the lateral sides of this column lie the anterior triangles which have passing through them the carotid arteries for the blood to the head, the jugular vein returning the blood, and the nerves. The form in this area is a receding one, light does not fall on it readily under the overhang of the jaw, so it is often in shadow.

The strong STERNOMASTOID muscle divides the anterior and posterior triangles. It is attached to the mastoid process of the skull, which lies behind the ear, runs diagonally forward and down to attach by two tendinous heads to the front of the sterno-clavicular joint and manubrium and to the upper part of the clavicle (medial one-third). This is an important form which can always be seen in the neck.

The area of the posterior triangle lies behind the sternomastoid muscle. It has passing through it diagonal muscles going forward and upward from the vertebral column and scapula to attach to the cervical vertebrae.

The big muscle on the top of the shoulder is the trapezius which is discussed fully later.

The LIGAMENTUM NUCHAE is a continuation in the neck of the ligaments which tie the vertebrae together. It is a tough thin sheet of strong fibres situated in the midline at the back of the neck. It is attached to the back of the cranium in the midline and the spines of the seven cervical vertebrae. Its free edge then spans between the cranium and the spine of the seventh cervical. Both the splenius and trapezius are attached to it. One sees an indentation often running up the back of the neck which is caused by pull on the edge of this ligament, and the muscle bundles mounding on either side of it.

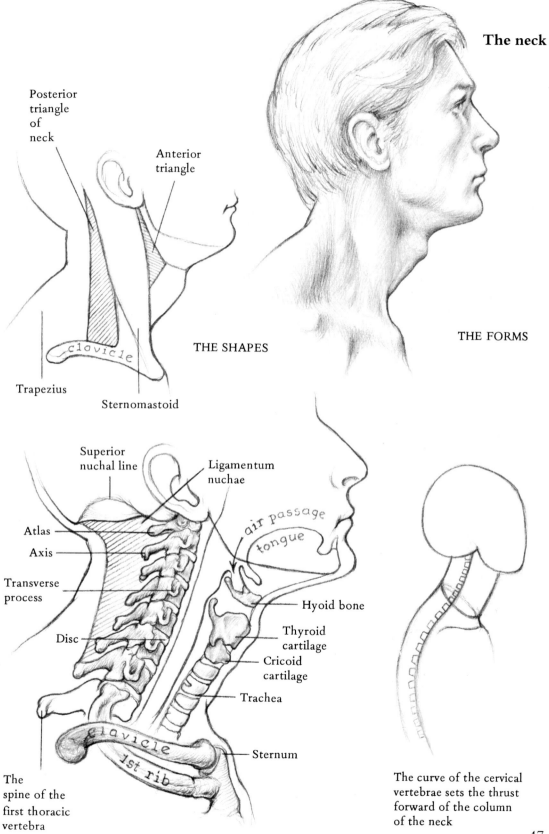

The neck

Posterior
triangle
of
neck

Anterior
triangle

THE SHAPES

THE FORMS

Trapezius

clavicle

Sternomastoid

Superior
nuchal line

Ligamentum
nuchae

air passage

tongue

Atlas

Axis

Transverse
process

Disc

Hyoid bone

Thyroid
cartilage

Cricoid
cartilage

Trachea

clavicle

1st rib

Sternum

The
spine of the
first thoracic
vertebra

The curve of the cervical
vertebrae sets the thrust
forward of the column
of the neck

The muscles of the chest

The PECTORALIS MAJOR is a large fan-shaped muscle on the chest wall. It has two parts or heads, as they are usually called, as origins from the clavicle and the rib cage. The clavicular head is attached to approximately one half of the anterior and medial part of the clavicle. The sternal head attaches to the area of the sterno-clavicular joint, the sternum, and the fifth and sixth costal cartilages. This is the powerful breast muscle of birds in which the sternum is expanded into a bony keel to provide a greater surface for attachment.

The muscle is inserted into the far edge (lateral lip) of the bicipital groove of the humerus. When it contracts, the humerus being freer to move than the thorax, changes position. The insertion has a special feature as the lower muscle bundles of the sternal head roll under as they pass from the chest to the humerus, in one twist. The bundles of lowest origin therefore become the bundles of highest insertion. The muscle bundles of the clavicular head are those of the lowest insertion. This plan provides for more mobility of the humerus.

When the arm is relaxed, this whole lower rolled border can be grasped in the hand. It creates the front 'wing' of the arm pit and is a form which can always be seen. At times the tiny form of the clavicular head can be seen as it passes in front of the sternal part to its low insertion. When the arm is brought forward, particularly against resistance, the two heads are seen often as separate entities contracting strongly. The main movement is adducting the arm (bringing it toward the midline).

The PECTORALIS MINOR has its origin from the third, fourth and fifth ribs, and is inserted near the tip of the coracoid process. It lies beneath the pectoralis major and is not a surface form, but it is important in movement because it assists in pulling the scapula forward around the chest wall and increases the reach of the arm.

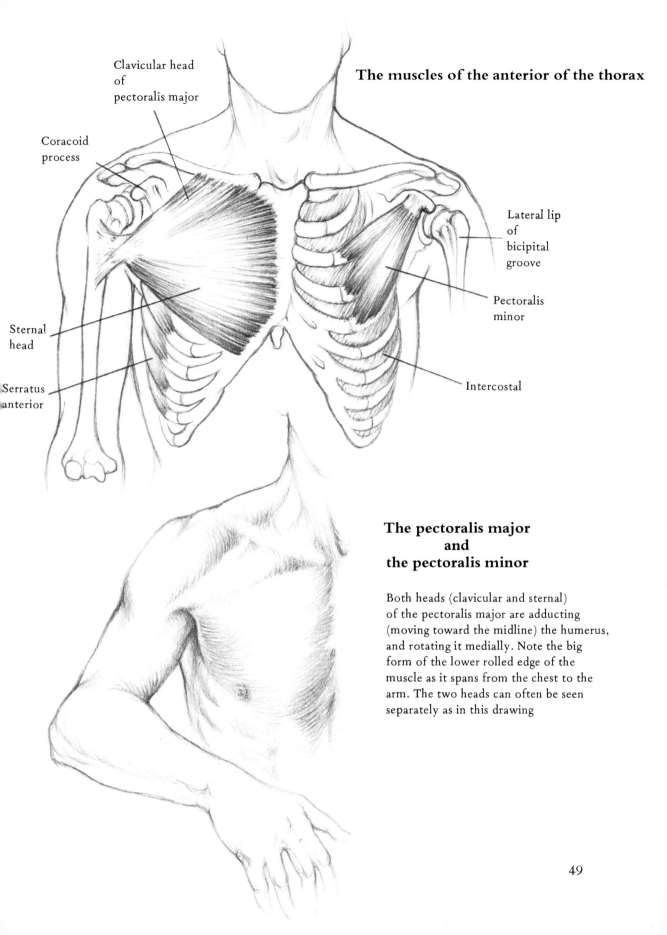

Clavicular head
of
pectoralis major

Coracoid
process

The muscles of the anterior of the thorax

Lateral lip
of
bicipital
groove

Pectoralis
minor

Sternal
head

Serratus
anterior

Intercostal

**The pectoralis major
and
the pectoralis minor**

Both heads (clavicular and sternal)
of the pectoralis major are adducting
(moving toward the midline) the humerus,
and rotating it medially. Note the big
form of the lower rolled edge of the
muscle as it spans from the chest to the
arm. The two heads can often be seen
separately as in this drawing

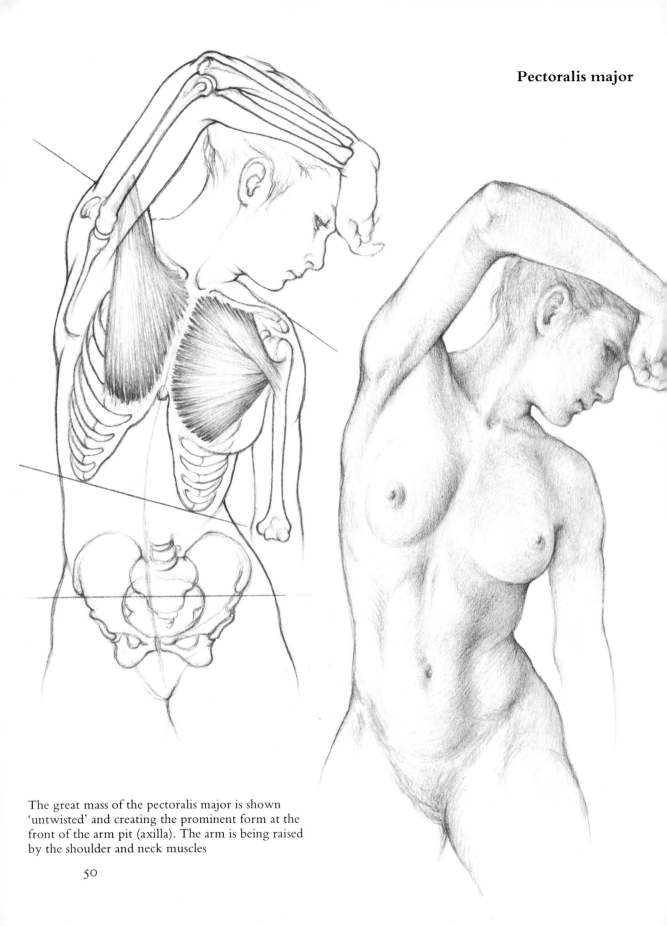

Pectoralis major

The great mass of the pectoralis major is shown 'untwisted' and creating the prominent form at the front of the arm pit (axilla). The arm is being raised by the shoulder and neck muscles

50

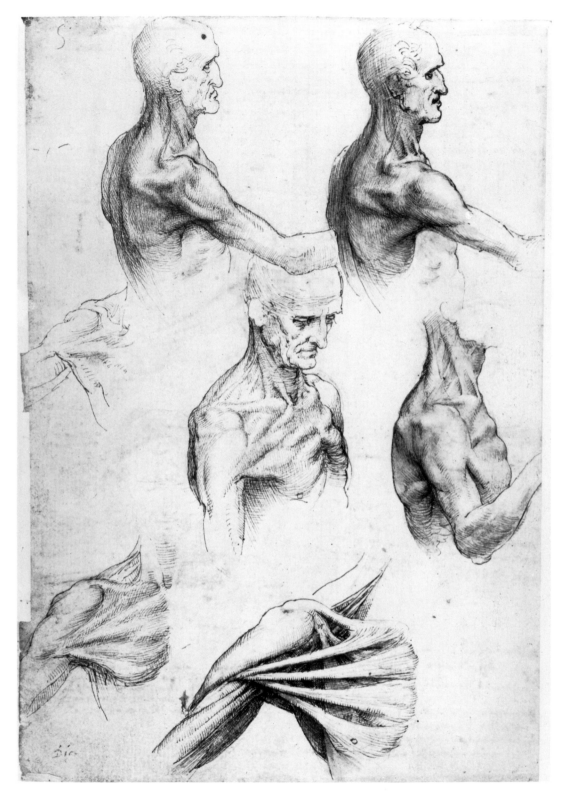

The movement of the bony structure of the trunk is also shown with the landmarks of the clavicles, costal margin and the position of the anterior superior iliac spines. The scapular movement and resultant form is also included

Muscles of the Chest by Leonardo da Vinci
Royal Library, Windsor Castle
Reproduced by gracious permission of
Her Majesty Queen Elizabeth II

51

The SERRATUS ANTERIOR is a flat sheet of muscle lying between the inner (ventral) surface of the scapula and the rib cage. Its origin is by fleshy digitations (fingers) from the upper eight or nine ribs which is the fixed point of the muscle. It is inserted along the inner side of the vertebral border of the scapula. The digitations from the lower five ribs converge on the inner side of the inferior angle of the scapula and it is those which most concern the artist as they are seen so frequently. They appear as rich little finger-like forms running at a slightly different angle than the ribs.

The serratus anterior is the main muscle concerned in pushing and punching actions and is important in raising the arm above the head. When the muscle contracts, the more movable scapula is pulled around the rib cage. Because of the concentration of muscle bundles at the inferior angle, the inferior angle of the scapula is strongly rotated and its form can be seen on the side of the thorax. Its upper muscle bundles acting with pectoralis minor increase the reach of the outstretched hand by pulling the upper part of the vertebral border and the coracoid process forward and around.

THE SERRATUS ANTERIOR
This is the chief muscle to draw the scapula forward
so that forward and upward arm movements can occur

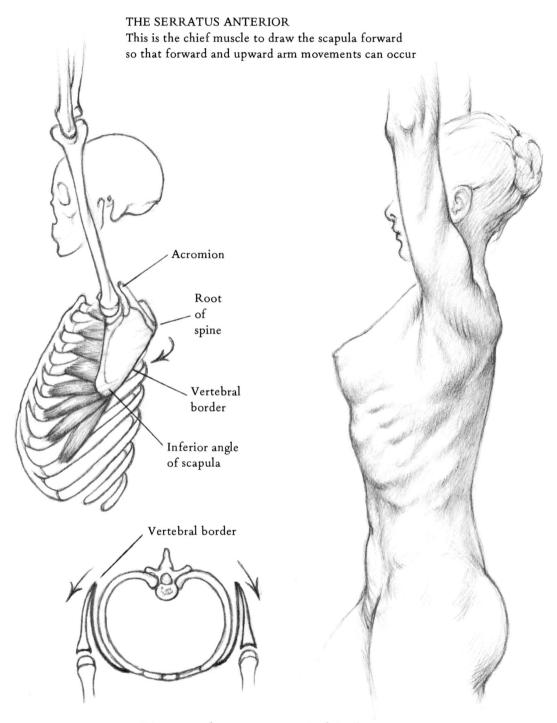

Acromion

Root
of
spine

Vertebral
border

Inferior angle
of scapula

Vertebral border

Diagram to show serratus anterior lying between
the ribs and the scapula with its origin on the
ribs and its insertion into the vertebral border
of the scapula

53

The muscles of the abdomen

Three flat muscles form the abdominal wall along with the rectus abdominis. They are arranged in three layers with their muscle bundles running in three different directions in the region of the waist. This is a strong and flexible arrangement both for movement and for binding between the rib cage and costal margin and the pelvis. They keep the abdominal viscera in place and are used to bend the trunk forward and to rotate the trunk. Their tendons are each flattened into a sheet called an aponeurosis, which blend together at the front of the abdomen and then split to pass in front and behind the rectus abdominis muscle to form a sheath for it. The flat form of this aponeurotic area can frequently be seen on either side of the lateral borders of the rectus straps.

The EXTERNAL OBLIQUE is the outermost layer and has its origin from the lower eight ribs on the antero-lateral aspect of the rib cage. These fleshy digitations of origin interlock like fingers with the digitations of the serratus anterior, and those of the latissimus dorsi. The lowest muscle bundles insert into the iliac crest between its mid-point and the anterior superior spine. The rest of the insertion is through the sheet of aponeurosis which covers the front of the abdomen. The lower edge of this aponeurosis is considered 'free' between the anterior superior spine and the pubic tubercle. It creates a linear tension between these two points, a definite landmark for the artist, and is called the inguinal ligament. It is curved down toward the thigh because the sheath covering the thigh muscles is attached to it and pulls it down slightly. The great vessels to the leg pass underneath it, going from the abdomen into the thigh. The aponeurosis contributes to the front of the sheath for the rectus abdominis and is then inserted into the linea alba.

The INTERNAL OBLIQUE has its origin from the anterior two-thirds of the iliac crest and from more than half of the inguinal ligament. It is inserted into the lower four ribs, contributes to the rectus sheath and is inserted into the linea alba.

The TRANSVERSUS has its origin from the inguinal ligament, the iliac crest, the transverse processes of the lumbar vertebrae and by fleshy slips from the inner surface of the lower six costal cartilages. It completely girdles the trunk as its aponeurosis adds to the rectus sheath and inserts into the linea alba.

The aponeurosis of these three muscles contribute to the covering for the scrotum as the testes descend before birth from within the abdomen, pass downward and forward over the pubis and carry the elongated and thinned aponeurosis over them.

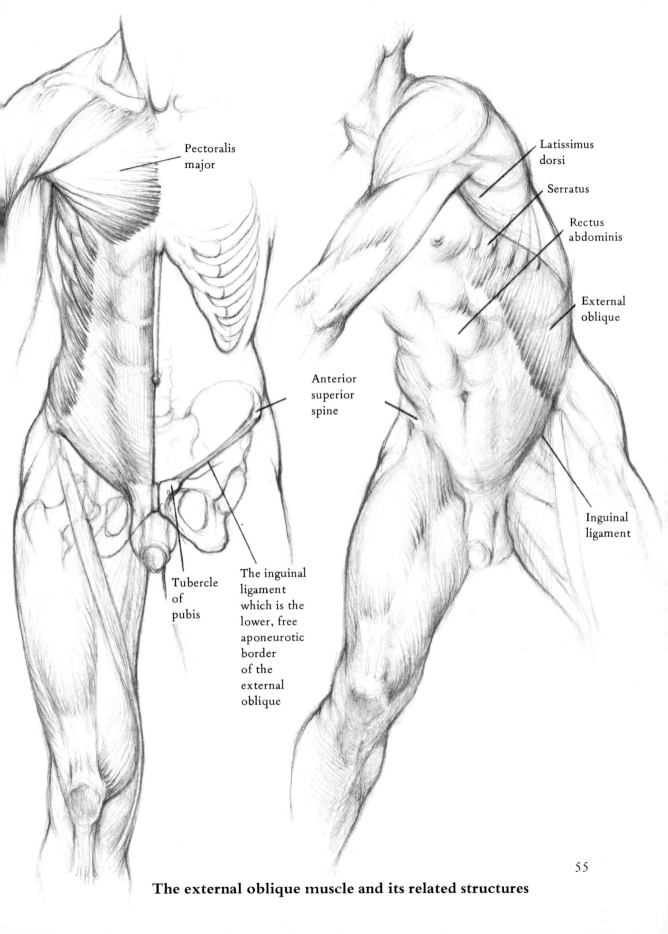

Pectoralis
major

Latissimus
dorsi

Serratus

Rectus
abdominis

External
oblique

Anterior
superior
spine

Inguinal
ligament

Tubercle
of
pubis

The inguinal
ligament
which is the
lower, free
aponeurotic
border
of the
external
oblique

55

The external oblique muscle and its related structures

The muscles of the abdomen

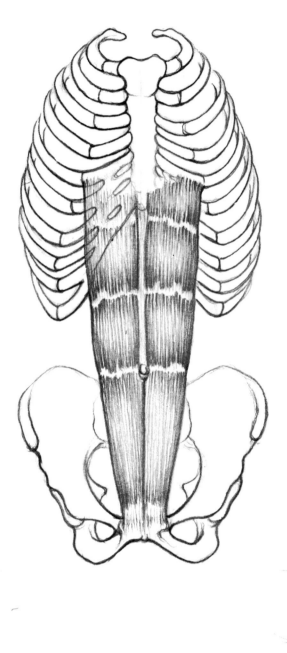

The rectus abdominis

The rectus abdominis muscle is composed of two straps attached above to the xiphoid process and the cartilages of the fifth, sixth and seventh ribs. Below it is attached to the front of the pubis. Each strap has an attachment about 76 mm (3 in.) across to the rib cage and about 25 mm (1 in.) across to the pubis. The lateral borders are therefore diagonal. There are fibrous horizontal inter-sections in the muscle because of its segmental origin. These are at the levels of the xiphoid process, the umbilicus and halfway between. The whole muscle is enclosed in a sheath formed by the waist muscles, discussed later. Above the umbilicus the pair of straps are separated and the sheath meets in the median line which is an indentation called the linea alba (white line). Below the umbilicus the pair are closer together but an indentation can often be seen here also

When the rectus abdominis contracts it brings the front of the rib cage and the front of the pelvis closer together. It is used to raise the body from a lying position to a sitting position

The rectus abdominis with its attachment to the rib cage above and the pubis below. The linea alba which separates the two straps, the lateral borders of the straps, and the segmental forms are shown

The rectus abdominis being stretched by the longitudinal group of muscles of the back

When the rectus abdominis
contracts it can cause forward
flexion of the trunk, and as shown
here, it can keep pressure against
the abdominal viscera

Diagram showing the curve of the
spine as it is brought into flexion by
the rectus abdominis contracting

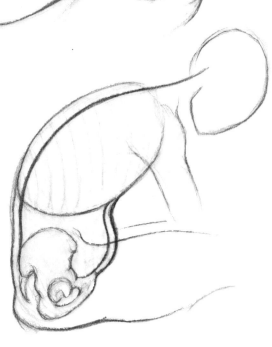

When the muscle is in its passive
state, the viscera have a pressure
against it caused by gravity, which
can create the 'pot belly'

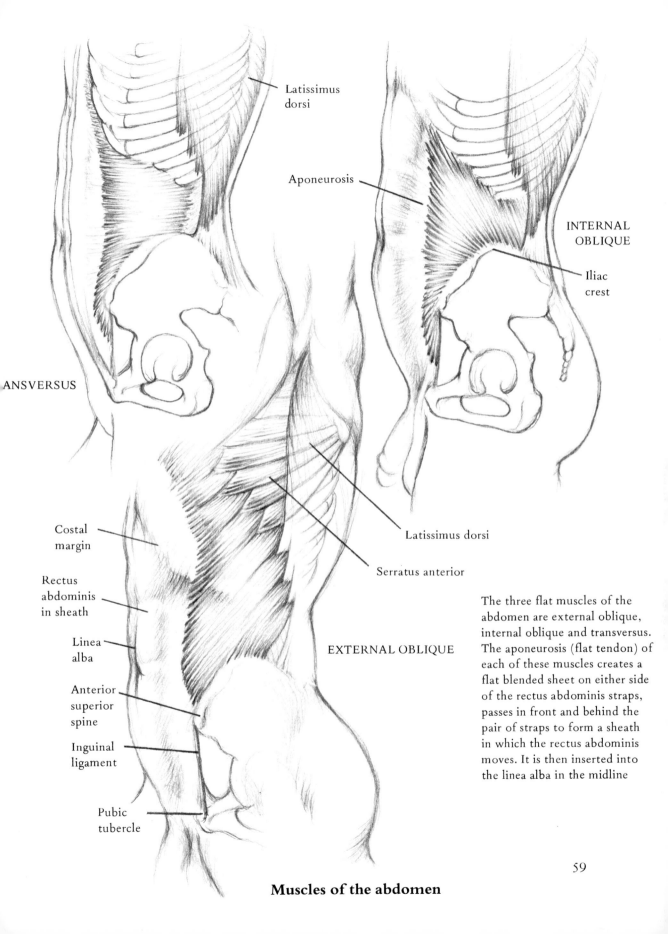

Latissimus dorsi

Aponeurosis

INTERNAL
OBLIQUE

Iliac
crest

ANSVERSUS

Costal
margin

Rectus
abdominis
in sheath

Linea
alba

Anterior
superior
spine

Inguinal
ligament

Pubic
tubercle

Latissimus dorsi

Serratus anterior

EXTERNAL OBLIQUE

The three flat muscles of the
abdomen are external oblique,
internal oblique and transversus.
The aponeurosis (flat tendon) of
each of these muscles creates a
flat blended sheet on either side
of the rectus abdominis straps,
passes in front and behind the
pair of straps to form a sheath
in which the rectus abdominis
moves. It is then inserted into
the linea alba in the midline

59

Muscles of the abdomen

The muscles of the back

The two SACROSPINALES are the long unifying muscles of the back and vertebral column. They are seen as long rounded forms on either side of the midline of the back, particularly in the lumbar area.

The origin of sacrospinalis is a thick, broad aponeurosis attached to the sacrum, to the medial and dorsal part of the iliac crest and to any ligaments in the area. On the surface of the trunk this appears as a smooth slightly curved area between the posterior iliac spines (the dimples).

Each sacrospinalis splits into three parts below the level of the twelfth rib, called the ilio-costo-cervicalis, the longissimus, and the spinalis.

The ILIO-COSTO-CERVICALIS is inserted into the ribs and into the transverse processes of the fourth to sixth cervical vertebrae. This makes a long direct tie between the neck and the sacrum and pelvis.

The LONGISSIMUS is inserted into all the transverse processes of the fifth lumbar and twelfth thoracic vertebrae, and into the lower ten ribs. Part continues upward to insert into the transverse processes of the second to sixth cervical vertebrae, and yet another part continues on to the skull to insert into the posterior margin of the mastoid process. Longissimus ties together the skull, vertebrae, ribs, sacrum and pelvis.

The SPINALIS is a small part attaching to the upper lumbar and lower cervical spines.

When the two sacrospinalis columns contract together they extend the vertebral column (bend it backward). When one contracts, the trunk is bent to the side. The muscles are most obvious in the lumbar region where the lumbar vertebrae are curved forward and are 'buried' more, so that a deeper cleft or furrow is seen in the midline.

The QUADRATUS LUMBORUM is a short, thick column of muscle arising from the posterior part of the iliac crest and inserting into the transverse processes of the lumbar vertebrae and into the lower border of the twelfth rib. The origin is wider than the insertion into the rib, so the lateral border of the muscle is at an angle. This can sometimes be seen and as the muscle lies beneath the sacrospinalis, its mass is added to the column in the lumbar area. It acts with sacrospinalis in extending the vertebrae.

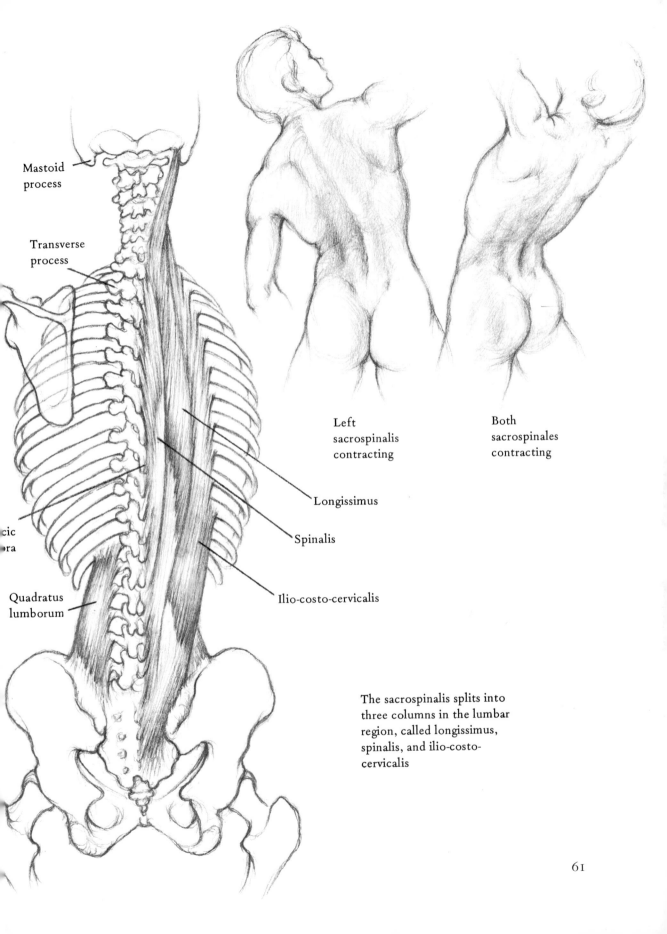

Mastoid
process

Transverse
process

...cic
...ra

Quadratus
lumborum

Left
sacrospinalis
contracting

Both
sacrospinales
contracting

Longissimus

Spinalis

Ilio-costo-cervicalis

The sacrospinalis splits into
three columns in the lumbar
region, called longissimus,
spinalis, and ilio-costo-
cervicalis

The SPLENIUS (meaning bandage) wraps around the side of the neck. It arises from the ligamentum nuchae and from the spines of the first six thoracic vertebrae. It spirals upward, attaching partly to the transverse processes of the first four cervical vertebrae, and partly to the posterior margin of the mastoid bone. When it contracts the head is drawn to one side and rotated so the face is turned to that side.

The LEVATOR SCAPULAE arises from the transverse processes of the first four cervical vertebrae and is inserted into the upper part of the medial border of the scapula. The muscle helps to steady the scapula and control it during arm movements. It also acts with the trapezius to lift the scapula and is used in rotation of the scapula.

The RHOMBOID MINOR arises from the lower part of the ligamentum nuchae and from the spines of the seventh cervical and first thoracic vertebrae. It is inserted into the vertebral border of the scapula at the root of the spine.

The RHOMBOID MAJOR arises from the spines of the second, third, fourth and fifth thoracic vertebrae. It is inserted into the vertebral border of the scapula between the root of the spine and the inferior angle. The rhomboids pull the scapula backward and upward as the direction of their muscle bundles indicate. They also steady the scapula during rotation. In a person with well developed muscles these two forms and their movement upward can be seen bulging under the trapezius, which lies over them. With the trapezius they are responsible for the mounding up of flesh between the vertebral border of the scapula and the vertebral column when the scapula is pulled back.

The SERRATUS POSTERIOR SUPERIOR arises from the lower cervical and upper thoracic spines and inserts into the second to fifth ribs.

The SERRATUS POSTERIOR INFERIOR arises from the lower thoracic and upper lumbar spines and is inserted into the ninth to twelfth ribs. Both of these muscles are used to stretch the rib cage when one breathes in.

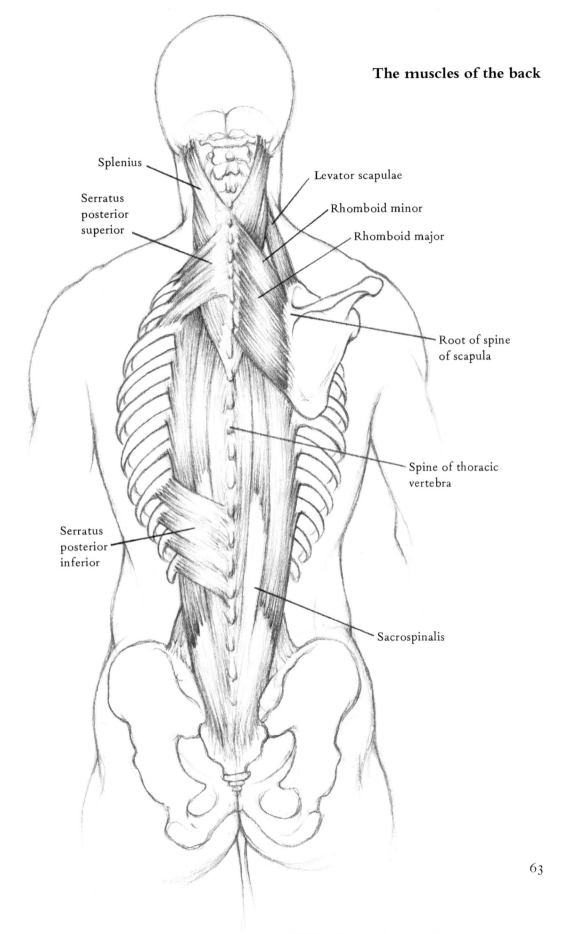

The muscles of the back

Splenius

Serratus
posterior
superior

Levator scapulae

Rhomboid minor

Rhomboid major

Root of spine
of scapula

Spine of thoracic
vertebra

Serratus
posterior
inferior

Sacrospinalis

The TRAPEZIUS is a triangular sheet of muscle covering the top of the shoulder, the back of the neck and the medial part of the thorax. It arises from the medial one-third of the superior nuchal line of the back of the skull, from the ligamentum nuchae and from the spines of the twelve thoracic vertebrae. Its muscle bundles run in three different directions. The upper ones pass downward and laterally to insert into the flattened lateral third of the clavicle. The middle muscle bundles pass almost horizontally to insert into the upper border of the spine of the scapula and medial margin of the acromion. The whole top of the shoulder is thus covered by trapezius. The lower muscle bundles pass upward and insert into the lower border of the spine and its tubercle, by an aponeurosis. The trapezius suspends the pectoral girdle and steadies it when a weight is being carried in the hand. During partial rotation of the scapula forward, the upper muscle bundles raise the point of the shoulder while the lower bundles pull down on the spine. In full rotation the lower bundles are stretched while the upper bundles are full contracted. The two parts are therefore antagonistic when this happens.

The LATISSIMUS DORSI has a broad aponeurotic origin extending from the seventh thoracic vertebrae (under cover of the trapezius), the spines of the lumbar and sacral vertebrae, to the lateral edge of the iliac crest. It has origin also by fleshy slips from the lower three ribs. This great sheet of muscle bundles converges upward, taking a half turn, to insert into the medial lip of the bicipital groove of the humerus. Like the pectoralis major, its lowest muscle bundles of origin become the highest of insertion. It forms the main part of the muscle mass of the posterior wall of the arm pit. The thick rolled edge of it can always be seen where the muscle leaves the trunk area to span across to the arm. The latissimus is used in all those movements in which the arm is brought back. It rotates the humerus forward in its socket and also adducts (brings toward the body) the arm. If one is hanging by the hands, the latissimus is the chief muscle in enabling the trunk to be raised. The inferior angle of the scapula lies under the latissimus and is held to the rib cage by it. The upper border of the muscle can often be seen crossing the scapula is this area.

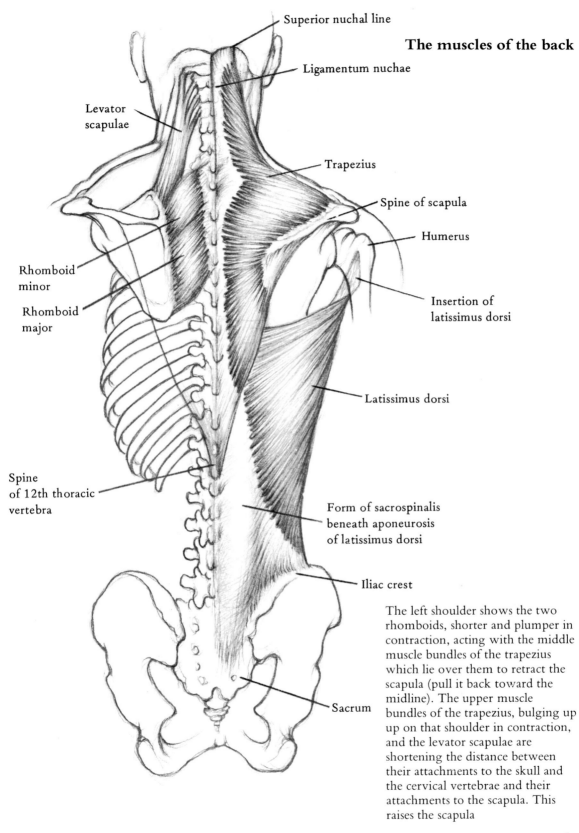

Superior nuchal line

The muscles of the back

Ligamentum nuchae

Levator
scapulae

Trapezius

Spine of scapula

Humerus

Insertion of
latissimus dorsi

Rhomboid
minor

Rhomboid
major

Latissimus dorsi

Spine
of 12th thoracic
vertebra

Form of sacrospinalis
beneath aponeurosis
of latissimus dorsi

Iliac crest

Sacrum

The left shoulder shows the two
rhomboids, shorter and plumper in
contraction, acting with the middle
muscle bundles of the trapezius
which lie over them to retract the
scapula (pull it back toward the
midline). The upper muscle
bundles of the trapezius, bulging up
up on that shoulder in contraction,
and the levator scapulae are
shortening the distance between
their attachments to the skull and
the cervical vertebrae and their
attachments to the scapula. This
raises the scapula

65

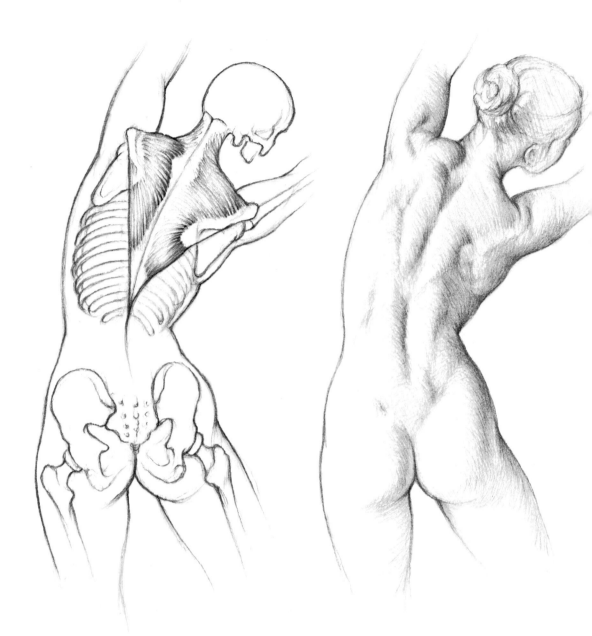

This is the action of the upper and lower muscle bundles of the trapezius in raising the point of the shoulder and rotating the scapula. The resultant forms of the parts contracting are shown in the figure drawing. Note that the aponeurotic areas which attach the muscle to the bones appear flat in comparison to the contracting parts of the muscle. Also, in the shoulder region when the arms are raised, the acromion is a very definite flat form just under the skin and the fleshy part of contracting muscles bulge over it

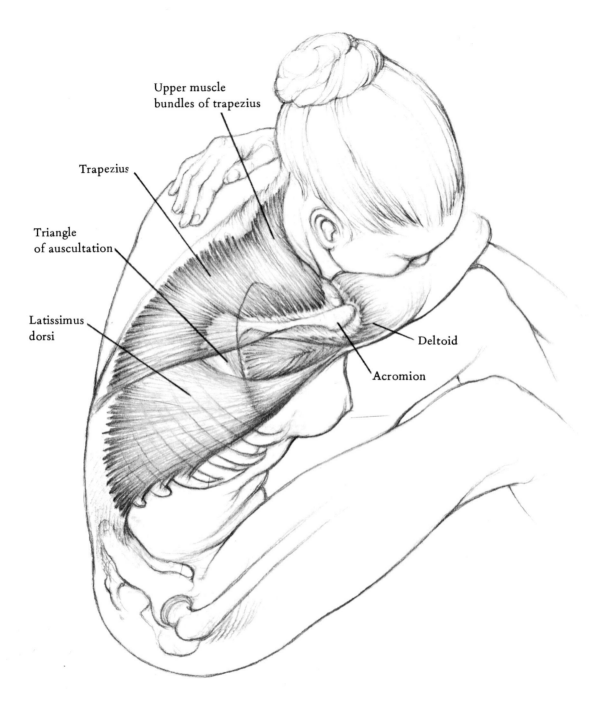

Upper muscle
bundles of trapezius

Trapezius

Triangle
of auscultation

Latissimus
dorsi

Deltoid

Acromion

THE SHOULDER
This shows the relationships of the trapezius muscle,
the latissimus dorsi muscle and the scapula from the
superior and lateral aspects

The upper muscle bundles of the trapezius are contracting and therefore bulging at the top of the shoulder as they pull the scapula up toward the head. The scapula must rotate when the arm is pulled forward. The inferior angle lies under the latissiums dorsi m. and creates a rounded form. Both the middle and lower muscle bundles of the trapezius and the latissimus dorsi are being stretched over the great rounded form of the bony thorax. The lower border of the trapezius, the upper border of the latissiumus dorsi and the vertebral border of the scapula create a triangular form, the triangle of auscultation.

The trunk

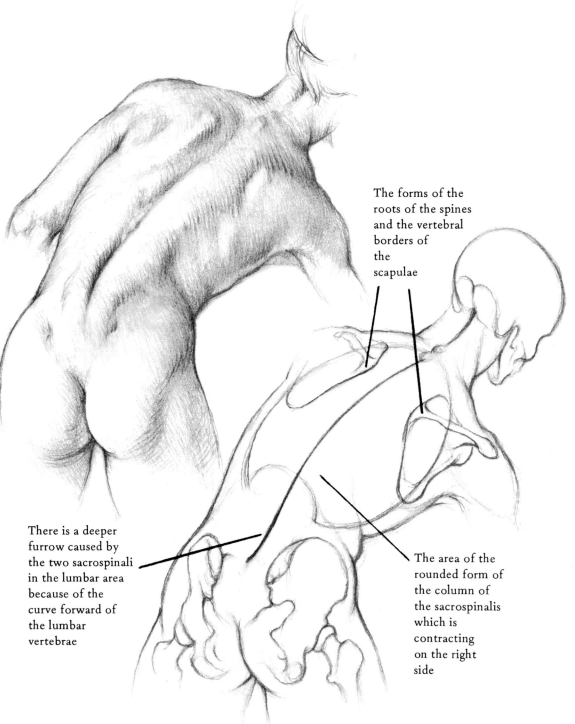

The forms of the roots of the spines and the vertebral borders of the scapulae

There is a deeper furrow caused by the two sacrospinali in the lumbar area because of the curve forward of the lumbar vertebrae

The area of the rounded form of the column of the sacrospinalis which is contracting on the right side

The deltoid

The DELTOID has its origin from the flattened lateral third of the clavicle, from the lateral border of the acromion and from the lower edge of the spine of the scapula. It completely covers the shoulder joint. Its insertion is into the deltoid tuberosity of the humerus. The muscle is divided into anterior, middle and posterior parts. The anterior part pulls the humerus forward (flexion of the arm) and the posterior part pulls the humerus backward (extension of the arm). The middle part is used in raising the arm and the internal structure of this section is structured for this function. Four tendinous septa which are attached to the acromion descend in the muscle and short muscle bundles are attached diagonally to these like the barbs of a feather. It is therefore called a multipennate muscle. This structure is of great importance to the artist because when the muscle bundles are plumper and shorter in contraction, these four septa appear as furrows in the muscle.

The CORACO-BRACHIALIS is a small muscle having its origin on the tip of the coracoid process and its insertion into the humerus. Its tiny form can often be seen in the axilla when the arm is raised. It helps draw the humerus forward.

The BRACHIALIS has its origin on the lower half of the front of the humerus. This takes the shape of a V around the deltoid tuberosity so the deltoid muscle fits into it. Its insertion is into the ulna. When it contracts it flexes the elbow joint and adds considerably to the bulge on the front of the upper arm as it lies just under the biceps and works with it.

The BICEPS has two tendinous origins called heads. The long head is attached to the scapula just above the glenoid fossa, spans the shoulder joint and comes to lie in the bicipital groove of the humerus, and is held down in that tunnel by a fibrous ligament. The short head is attached to the tip of the coracoid process. The long and short heads meet about the middle of the arm to form the belly of the biceps. The insertion of the muscle is into the tuberosity of the radius. The biceps flexes the elbow-joint and it is also the powerful supinator of the forearm. Because the radius can rotate in its socket, when biceps contracts, the radius is pulled over the ulna and the forearm and hand are turned over (supinated). This point is discussed in full later.

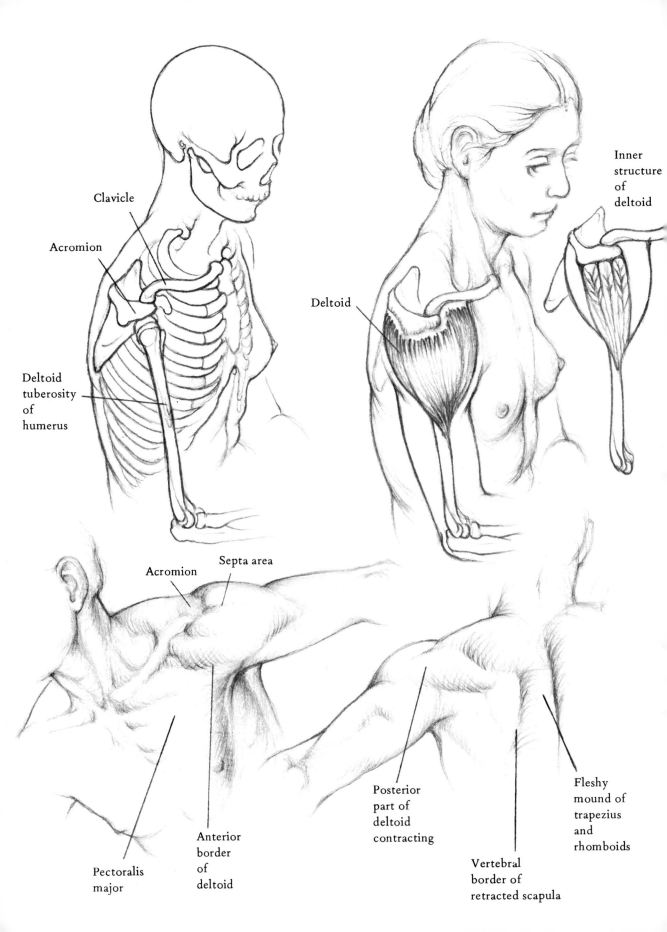

Clavicle

Acromion

Deltoid
tuberosity
of
humerus

Inner
structure
of
deltoid

Deltoid

Acromion

Septa area

Pectoralis
major

Anterior
border
of
deltoid

Posterior
part of
deltoid
contracting

Vertebral
border of
retracted scapula

Fleshy
mound of
trapezius
and
rhomboids

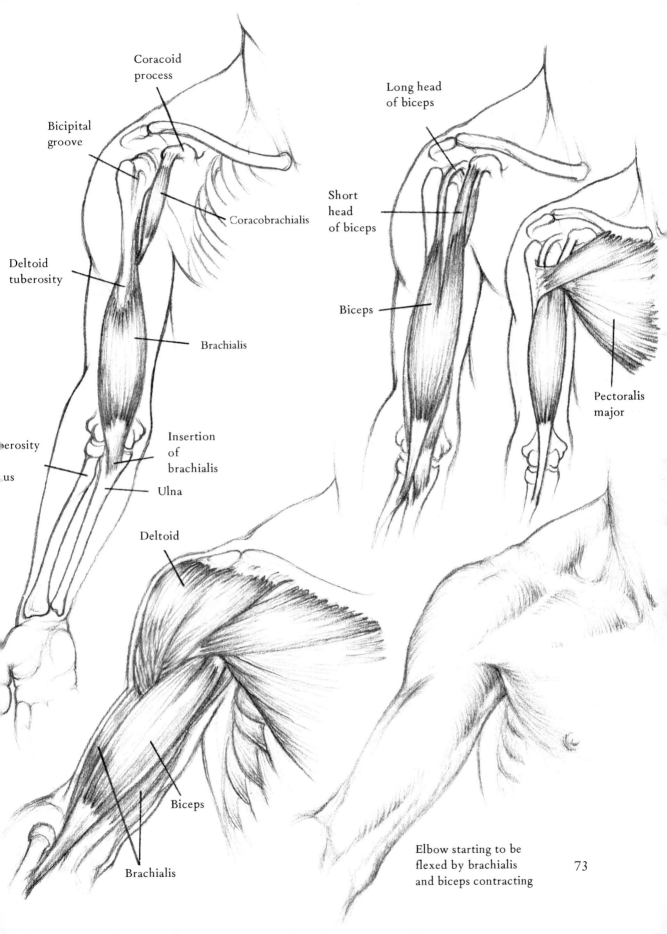

Coracoid process

Bicipital groove

Coracobrachialis

Deltoid tuberosity

Brachialis

...erosity

...us

Insertion of brachialis

Ulna

Deltoid

Biceps

Brachialis

Long head of biceps

Short head of biceps

Biceps

Pectoralis major

Elbow starting to be flexed by brachialis and biceps contracting

73

The bones of the arm

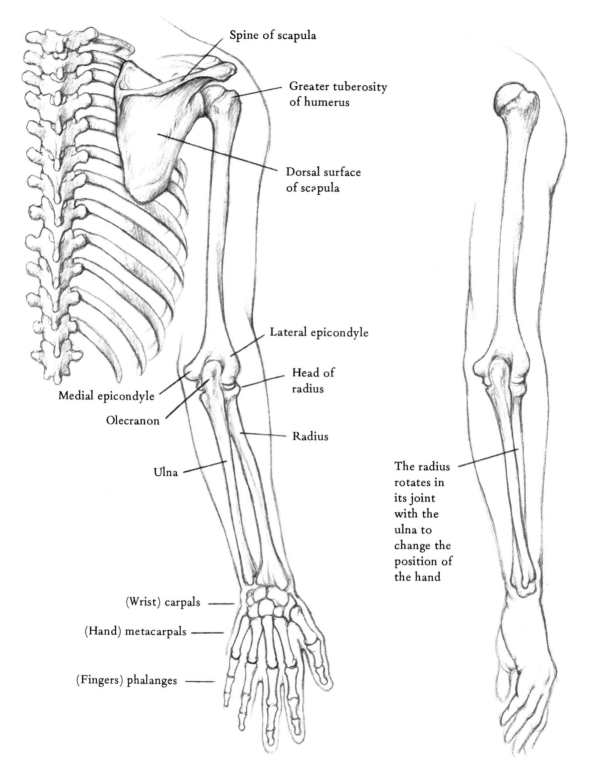

Spine of scapula

Greater tuberosity
of humerus

Dorsal surface
of scapula

Lateral epicondyle

Head of
radius

Medial epicondyle

Olecranon

Radius

Ulna

(Wrist) carpals

(Hand) metacarpals

(Fingers) phalanges

The radius
rotates in
its joint
with the
ulna to
change the
position of
the hand

The triceps muscle and the muscles of the dorsal surface of the scapula

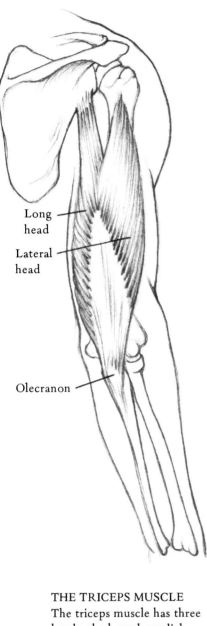

Long head

Lateral head

Olecranon

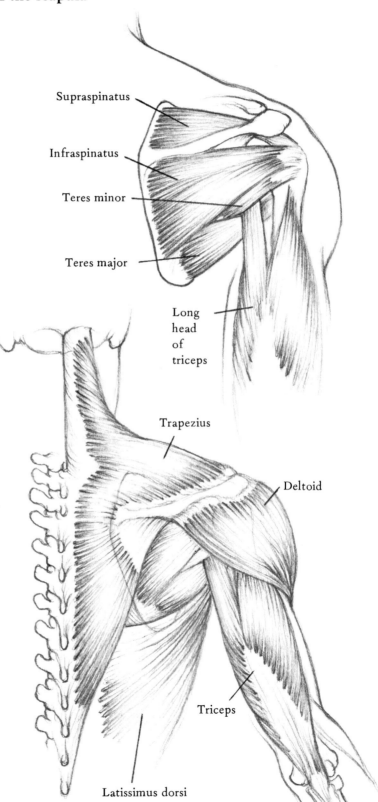

Supraspinatus

Infraspinatus

Teres minor

Teres major

Long head of triceps

Trapezius

Deltoid

Triceps

Latissimus dorsi

THE TRICEPS MUSCLE
The triceps muscle has three heads, the lateral, medial and long. The medial head which is not shown lies beneath the other two and is attached to the shaft of the humerus. Note the large common tendon of the three heads. It appears as a more flattened form of the back of the upper arm

The TRICEPS muscle is composed of three heads, all of which are inserted by a common tendon into the posterior part of the olecranon. The long head has its origin from the border of the scapula just below the glenoid fossa. The medial head, which lies beneath the other two, arises from the lower three-quarters of the posterior surface of the humerus. The lateral head has a linear attachment from the humerus posterior to the deltoid tuberosity. The common tendon of insertion begins about the middle of the arm and attaches to the posterior and upper surface of the olecranon. The muscle is the only one on the back of the arm and is the great extensor of it, pulling the humerus back and also closer to the thorax.

The SUPRASPINATUS muscle arises on the dorsal surface of the scapula above the spine of the scapula. Its muscle bundles converge under the acromion and it is inserted by tendon into the highest part of the tuberosity of the humerus. It is involved with the deltoid in raising the arm.

The INFRASPINATUS muscle arises from the large part of the dorsal surface of the scapula below the spine. It is a thick muscle and its rounded form can often be seen bounded by the edge of the deltoid and the trapezius.

Its tendon is inserted next to that of supraspinatus into the tuberosity of the humerus. It acts with the posterior part of the deltoid to rotate the head of the humerus backward in its socket and also stabilizes it from sliding out of the shallow socket when the arm is raised.

The TERES MAJOR muscle has its origin from the dorsal surface of the inferior angle of the scapula. Its tendon passes to the front beneath the humerus to attach to the medial lip of the bicipital groove, and lies behind the tendon of the latissimus dorsi. The muscle rotates the head of the humerus forward in its socket and draws the humerus backward. The teres major and the infraspinatus often appear as one form bulging over the upper border of the latissimus dorsi.

The TERES MINOR arises from the lateral border of the scapula and it is inserted into the tuberosity of the humerus just below the insertion of infraspinatus. It helps in rotating the humerus backward in its socket.

The SUBSCAPULARIS MUSCLE (not seen on the surface) arises from the ventral surface of the scapula and is inserted into the lesser tuberosity of the humerus. It also stabilizes the head of the humerus and helps rotate the humerus forward.

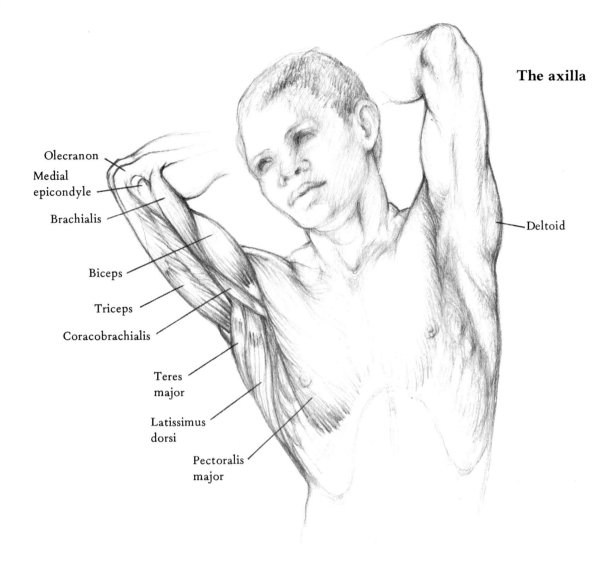

Olecranon

Medial
epicondyle

Brachialis

Biceps

Triceps

Coracobrachialis

Teres
major

Latissimus
dorsi

Pectoralis
major

Deltoid

These are the structures which comprise the axilla
and the resulting forms which can be seen very
frequently. As his left arm is rotated forward more,
so more of the deltoid muscle comes into view

The elbow joint and the upper radio–ulnar joint

The humerus has two articular surfaces, the CAPITULUM which is a rounded head and the TROCHLEA which is spool-shaped. These create joints with the articular surfaces on the head of the radius and the trochlear notch on the ulna. This whole unit acts as a hinge joint with the biceps and brachialis flexing it, and the triceps extending it.

The upper radio–ulnar joint is formed by the articulation between the head of the radius and an articular notch on the ulna. The fibrous annular ring in which the head of the radius is held completes a ring. The head can pivot within this ring while being held firmly by it. To this annular ring is attached the LATERAL LIGAMENT of the elbow which spans the joint to attach to the humerus below the lateral epicondyle. The MEDIAL LIGAMENT of the elbow is attached to the medial epicondyle and the ulna. Both these ligaments prevent medial and lateral displacement.

When the radius pivots medially, the hand is turned over so that the thumb is carried to the medial side (the side closest to the body). This movement is called pronation. When the radius pivots laterally it brings the thumb to the lateral side. This movement is called supination.

The INTEROSSEUS MEMBRANE is a tough fibrous sheet joining radius to ulna. With an impact on the hand which usually is on the thumb side, the force travels up the radius and is then transferred partially over to the ulna by this membrane.

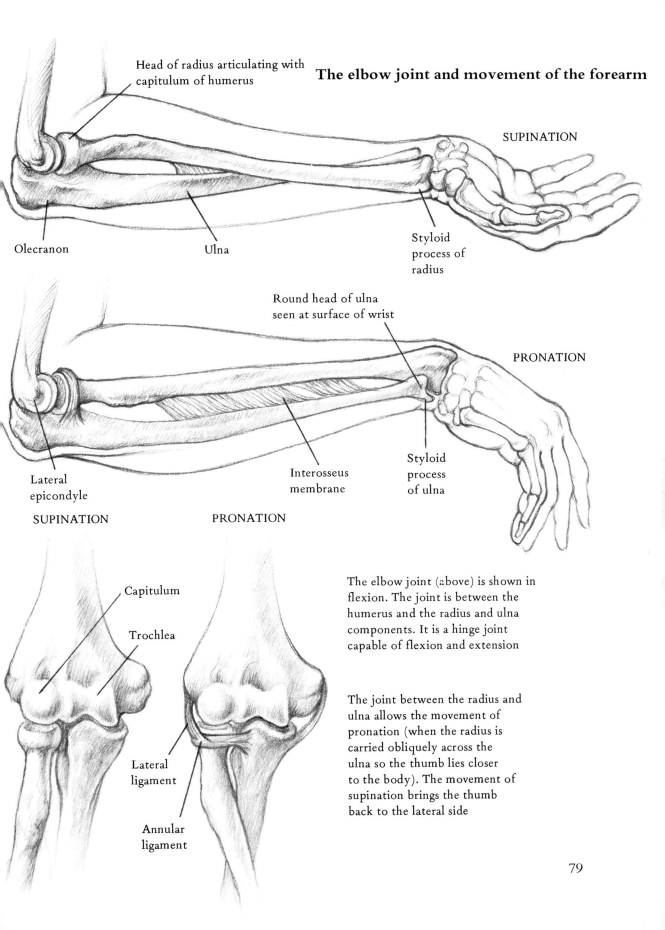

Head of radius articulating with
capitulum of humerus

The elbow joint and movement of the forearm

SUPINATION

Olecranon

Ulna

Styloid
process of
radius

Round head of ulna
seen at surface of wrist

PRONATION

Lateral
epicondyle

Interosseus
membrane

Styloid
process
of ulna

SUPINATION

PRONATION

Capitulum

Trochlea

Lateral
ligament

Annular
ligament

The elbow joint (above) is shown in
flexion. The joint is between the
humerus and the radius and ulna
components. It is a hinge joint
capable of flexion and extension

The joint between the radius and
ulna allows the movement of
pronation (when the radius is
carried obliquely across the
ulna so the thumb lies closer
to the body). The movement of
supination brings the thumb
back to the lateral side

The flexor region of the forearm

The muscles on the front or flexor aspect of the forearm are concerned with rotating the radius, with flexing the wrist through their attachments to the metacarpal bones, and with flexing the fingers so one can grip, through their attachments to the phalanges.

Much of the movement of the hand is controlled by muscle bundles contracting high in the forearm. The tendons are long and thin, crowded together at the lower ends of the radius and ulna where some of them can be seen before they pass to their insertions into the hand and finger bones.

The deep layer of muscles

The SUPINATOR arises from the lateral ligament of the elbow, from the annular ring of fibre and from the back of the ulna. It winds forward to insert into the shaft of the radius in its upper one-third. It rotates the radius to bring the palm of the hand facing forward.

The PRONATOR TERES arises from the humerus above the medial epicondyle, from the common tendon, and a small area of the ulna. It passes obliquely downward to insert into the middle of the lateral surface of the radius. It rotates the radius to turn the palm of the hand backward and is the antagonist of the supinator.

The PRONATOR QUADRATUS is attached above the wrist to both the radius and ulna. When it contracts, since the radius is the bone capable of rotating, it helps the pronator teres to turn the palm backward.

The FLEXOR POLLICIS LONGUS has its origin from the middle two-fourths of the anterior surface of the radius. Its tendon is inserted into the end bone of the thumb (the distal phalanx) for flexion of the thumb.

The FLEXOR DIGITORUM PROFUNDUS arises from the front of the shaft of the ulna and from the ulnar half of the inerosseus membrane. It divides into four tendons about the middle of the arm which pass to the four fingers and are inserted into their distal phalanges. The tendon to the index finger is usually more separated. Flexor digitorum profundus acts on the tips of the fingers to flex them.

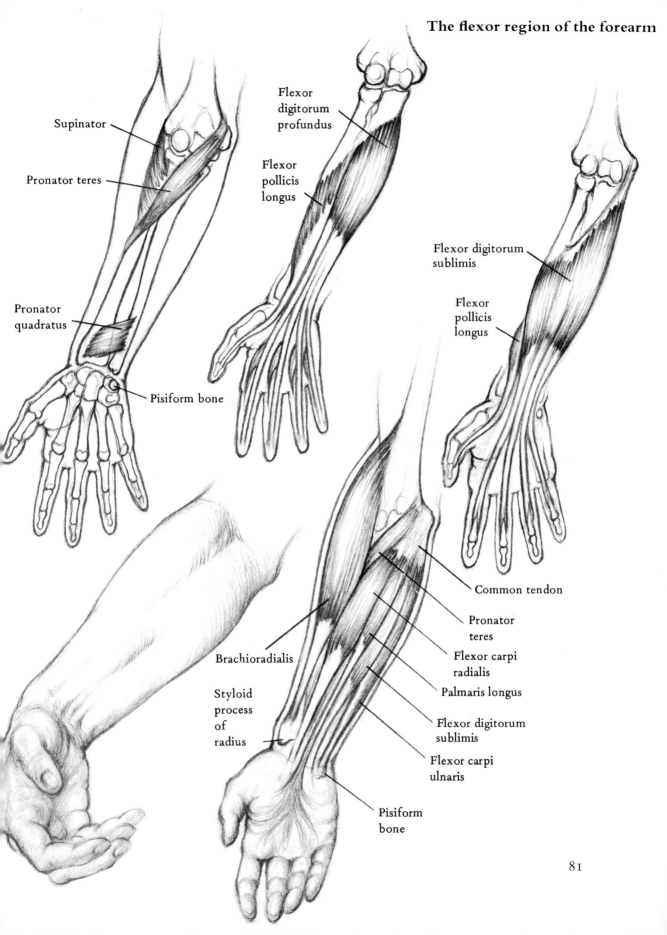

Supinator

Pronator teres

Flexor digitorum profundus

Flexor pollicis longus

Flexor digitorum sublimis

Flexor pollicis longus

Pronator quadratus

Pisiform bone

Common tendon

Pronator teres

Flexor carpi radialis

Palmaris longus

Flexor digitorum sublimis

Flexor carpi ulnaris

Brachioradialis

Styloid process of radius

Pisiform bone

81

The superficial layer of muscles

The origin of the FLEXOR DIGITORUM SUBLIMIS is from the medial epicondyle, the medial ligament, the common tendon and the anterior surface of the radius. It divides into four bellies and then into four tendons. The tendons to the middle and ring fingers lie in front of the tendons to the index and little finger. Their insertion is into the middle phalanges of the fingers. They work with the tendons of Flexor Digitorum Profundus to flex the fingers.

The BRACHIORADIALIS has its origin from the lateral side of the humerus above the lateral condyle and inserts into the lateral side of the lower end of the radius above the styloid process. It is a most important form as a landmark on the forearm as it can always be seen. It can be grasped between your fingers and thumb in the region of the elbow. It is called the 'carrying muscle' as it flexes the elbow joint and stands out prominently if one is carrying a heavy object when the elbow is bent.

The FLEXOR CARPI RADIALIS arises by common tendon from the medial epicondyle of the humerus and is inserted into the base of the second metacarpal bone. It does what its name says, flexes the wrist on the radial side and rotates the hand inward.

The PALMARIS LONGUS also arises from the common tendon. It has a short thin belly and a long thin tendon which passes just under the skin into the hand, in the midline. The tendon spreads out into the palmar aponeurosis which is attached to the skin of the palm and keeps the skin tight to the palm for gripping. The muscle is also a flexor of the wrist.

The origin of the FLEXOR CARPI ULNARIS is from the common tendon which is attached to the medial epicondyle of the humerus, and from the olecranon and posterior aspect of the ulna. It is inserted into the pisiform bone at the ulnar side of the wrist. The pisiform bone is not a true carpal bone but is called a sesamoid bone (a seed) developing in the flexor carpi ulnaris tendon. This bone, in turn, is attached by ligament to the base of the fifth metacarpal, and can be felt easily in the hand. The muscle acts with the flexor carpi radialis to flex the wrist and it also acts strongly in adducting the hand, pivoting it at an angle to the forearm toward the body.

The thumb muscles

The ABDUCTOR POLLICIS LONGIS arises from the posterior surface of the ulna, the interosseus membrane and the surface of the radius and is inserted into the radial side of the base of the first metacarpal. It pulls the thumb away from the axial line.

The EXTENSOR POLLICIS BREVIS arises from the radius and the interosseus membrane. Its tendon passes with that of the abductor through a groove on the pack of the radius and it inserts into the base of the proximal phalanx. It extends the thumb (backwards).

The EXTENSOR POLLICIS LONGUS arises from the middle part of the shaft of the ulna and from the interosseus membrane. Its long tendon passes into a groove on the back of the radius which serves as a pulley, as the tendon changes to an oblique direction here to finally insert into the base of the distal phalanx. This tendon can readily be seen when the thumb is extended and often next to it, the brevis tendon.

These three muscles create a definite form on the arm of muscular persons, and a subtle form, which should not be missed, on others. Also, along the line of the longus tendon when the thumb is extended is a plane change from the back of the hand to the side of the thumb.

The extensor region of the forearm

The wrist and finger muscles

There are three muscles inserted into the bases of three metacarpals, which act to extend the wrist. These, with the muscles which extend the fingers arise from a common tendon attached to the lateral epicondyle. There is one exception, extensor indicis.

EXTENSOR CARPI ULNARIS is inserted into the base of the fifth metacarpal. It stabilizes the wrist when the hand is clenched, extends the wrist, and helps the flexor carpi ulnaris to adduct it.

EXTENSOR CARPI RADIALIS LONGUS is inserted into the base of the second metacarpal.

EXTENSOR CARPI RADIALIS BREVIS is inserted into the base of the third metacarpal.

The tendons of these last two muscles are crossed by those of the thumb muscles. These two muscles have a synergic action with the flexors of the fingers for when the figers are clenched in flexion, they steady the wrist. They also extend the wrist.

EXTENSOR INDICIS is a separate thin muscle arises from the posterior surface of the shaft of the ulna. Its tendon joins that of extensor digitorum passing to the index finger. It is an extra extensor of the finger.

EXTENSOR DIGITI V is a thin muscle, usually connected to extensor digitorum, and they both have a tendon passing to the little finger.

EXTENSOR DIGITORUM has a large common belly of muscle bundles which divide into four tendons for each of the four fingers. These four tendons can be seen on the back of the hand especially when the fingers are extended. They are apparent as they pass over the knuckles (metacarpal-phalangeal joints), and then they seem to disappear quickly on the back of the fingers. Examine your own hand for these facts. On the back of the fingers the tendons lose their long cord-like form and become flattened fibrous sheets called dorsal expansions. The fibres of a dorsal expansion insert into the base of the middle phalanx, while slips from the sides insert into the base of the distal phalanx. When the fist is clenched, the tendons slide sideways off the knuckles, especially the knuckle of the index finger.

All of these actions are brought about by muscle bundles contracting in the forearm. There will therefore be form change there as well as the change of positions of the hand and wrist.

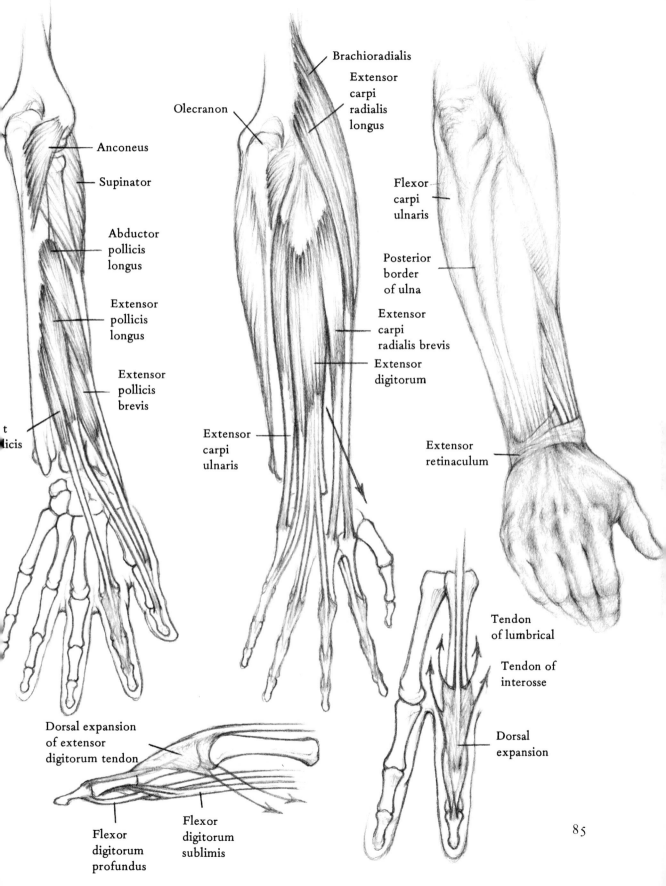

Brachioradialis

Extensor
carpi
radialis
longus

Olecranon

Anconeus

Supinator

Flexor
carpi
ulnaris

Abductor
pollicis
longus

Posterior
border
of ulna

Extensor
pollicis
longus

Extensor
carpi
radialis brevis

Extensor
digitorum

Extensor
pollicis
brevis

t
licis

Extensor
carpi
ulnaris

Extensor
retinaculum

Tendon
of lumbrical

Tendon of
interosse

Dorsal
expansion

Dorsal expansion
of extensor
digitorum tendon

Flexor
digitorum
profundus

Flexor
digitorum
sublimis

The posterior border of the ulna

The posterior border of the ULNA, a sharp edge of bone running from the olecranon process to the styloid process is of particular importance as a landmark for the artists. Because the bone of this border is subcutaneous it can be felt from your elbow to the wrist. On almost every arm it appears as a furrow with the flexor muscles and the extensor muscles bulging on either side of it. The extensors are going to the back (dorsum) of the hand to pull the wrist and hand back. The flexors are going to the palm side to bend the wrist and bring the fingers into the grasping position.

Towards the wrist the muscle bundles converge into tendons and then pass from the forearm to attach to the carpal bones, the metacarpals and the phalanges. It is this change from the great mass of muscle bundles to the much smaller mass of tendons which causes the tapering towards the wrist area.

When the arm is hanging loosely by the side the hand can be turned through nearly 360 degrees (as compared to approximately 140 degrees when the elbow is flexed as in the preceding drawings). This is because the head of the humerus can rotate very freely in that position and the pectoral girdle also can take part in the movement.

It helps greatly in understanding to try all of these movements of your own arms in front of a mirror where you can see not only the movements but the bony landmarks.

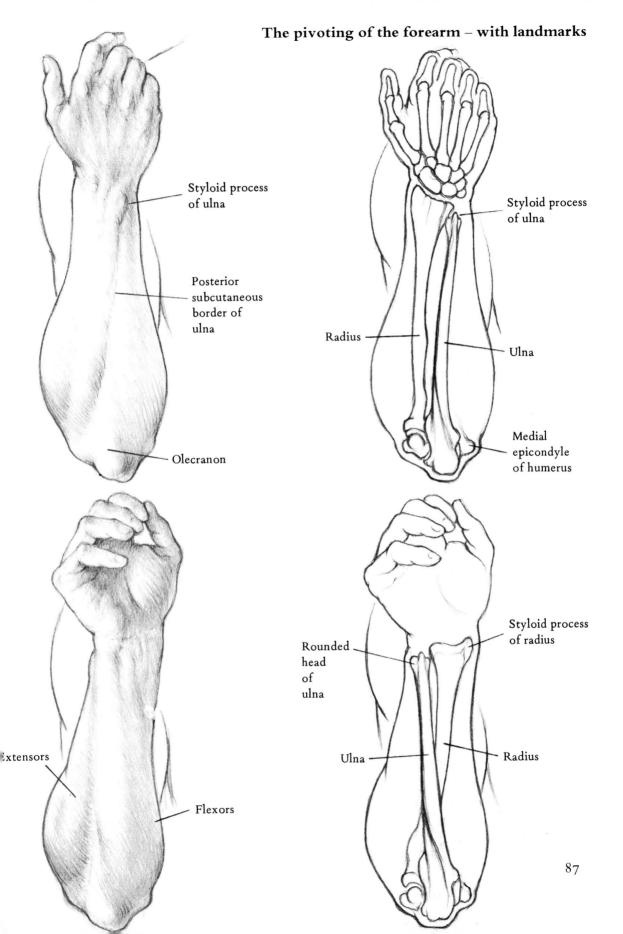

Styloid process
of ulna

Posterior
subcutaneous
border of
ulna

Olecranon

Styloid process
of ulna

Radius

Ulna

Medial
epicondyle
of humerus

Extensors

Flexors

Rounded
head
of
ulna

Styloid process
of radius

Ulna

Radius

87

The bones, muscles and movements of the hand

The CARPAL bones are eight in number and are cuboidal in form. Their sides have articular surfaces where they make joints with each other. They are all held together tightly by ligaments binding them to each other.

The wrist bends at the joint between the carpal bones and the radius. Four movements are possible here which you can try yourself. The wrist can flex (bend forward), extend (bend backwards), abduct (the hand moves away from the body), adduct (the hand moves toward the body). By using these four movements in sequence a circular motion can be obtained.

The carpal bones form an arch and the curve of it is distinctly visible when the wrist is bent.

The METACARPALS are five in number and are the bones of the hand. The first metacarpal is that of the thumb. Their joints with the carpal bones allow for different movements of importance to the artist. The fourth and fifth metacarpals have a hinge joint with the carpals and can flex, so the little finger and the ring finger can fold in more for gripping and in making a fist. This causes a 'drop away' plane on this side of the hand. The third and second metacarpals are immobile as they are locked into the joint. The first metacarpal acts on a plane at right angles to those of the palm, so the thumb structure lies almost at a right angle when the fist is clenched, making two definite planes.

The PHALANGES are the bones of the fingers and thumb. Note there are three for each finger and only two for the thumb. It is important to realize that the metacarpal-phalangeal joint is set back well into the substance of the hand. If you examine the back of your hand you will see there is about an inch of 'webbing' between the fingers before the separation of them.

The INTEROSSEI MUSCLES (meaning between the bones), are seven in number, four dorsal and three palmar. The dorsal interossei fill the spaces between the metacarpals, and arise from the sides of them. They are inserted by tendon into the lateral sides of the proximal phalanx and partly into the extensor dorsal expansion. They pull the fingers away from the axial line through the middle finger, and the middle finger can waggle from side to side. The little finger is pulled away from the axial line by abductor digiti v. The palmar interossei arise from the palmar surface of the metacarpals and their tendons are inserted partly into the proximal phalanx and partly into the dorsal expansion. They pull the fingers to the axial line.

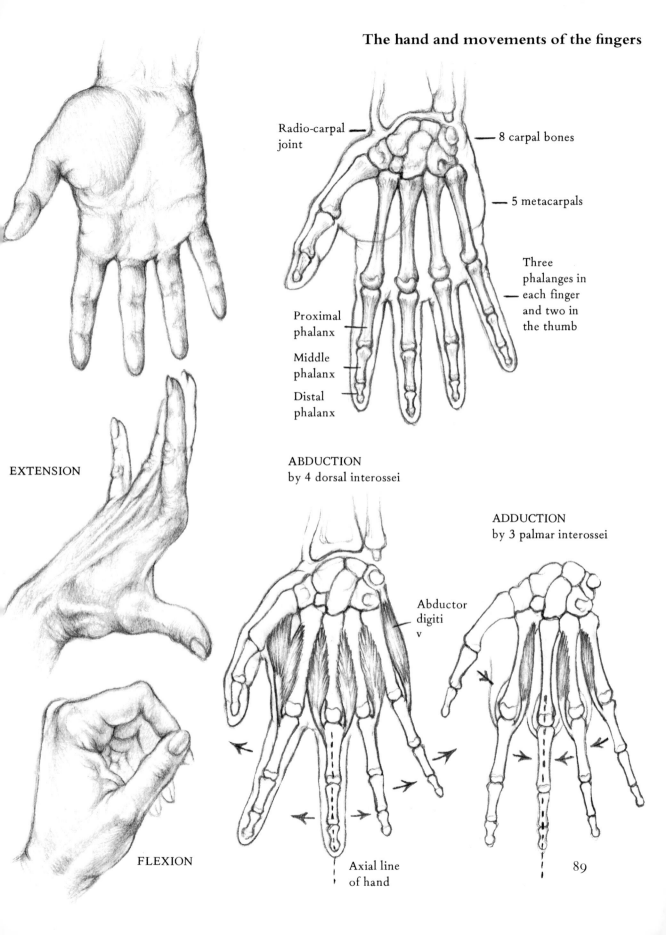

Radio-carpal
joint

8 carpal bones

5 metacarpals

Three
phalanges in
each finger
and two in
the thumb

Proximal
phalanx

Middle
phalanx

Distal
phalanx

EXTENSION

ABDUCTION
by 4 dorsal interossei

ADDUCTION
by 3 palmar interossei

Abductor
digiti
v

FLEXION

Axial line
of hand

89

The thumb muscles

Three muscles form the bulk of the ball of the thumb, with their origins from the flexor retinaculum of the wrist and the related carpal bones. The term pollicis is from pollex meaning thumb.

The muscle bundles of the OPPONENS POLLICIS pass diagonally downward and laterally to insert along the whole length of the first metacarpal. It bends the metacarpal toward the axial line, which is called opposition, where the palmar surface of the tip of the thumb can rest on the palmar tip of the little finger if its opponens is working.

The ABDUCTOR POLLICIS BREVIS is inserted into the proximal phalanx of the thumb. It draws forward at right angles to the palm of the hand and also pulls it medially.

The FLEXOR POLLICIS BREVIS muscle is also inserted into the base of the proximal phalanx and blends with the opponens muscle. It acts with the opponens in rotating the metacarpal medially, and flexes the metacarpal.

The ADDUCTOR POLLICIS lies deep in the palm and arises from the middle metacarpal, two carpal bones and carpal ligaments. It is inserted into both sides of the base of the proximal phalanx. It draws the metacarpal across the palm and keeps the thumb applied to the palm.

The tendon of FLEXOR DIGITORUM PROFUNDUS passes in front of the carpal bones and beneath the flexor retinaculum to enter the hand and proceed to its insertion into the base of the distal phalanx. From the lateral sides of the tendons to the four fingers, four muscles arise in the palm called lumbricales. Overlying it is the tendon of FLEXOR DIGITORUM SUBLIMIS which splits in the area of the middle phalanx to pass to its insertion on the middle phalanx. These two muscles flex the fingers.

The little finger muscles

ABDUCTOR DIGITI V has its origin from the pisiform bone and is inserted into the base of the proximal phalanx of the little finger. It pulls the little finger away from the axial line.

OPPONENS DIGIT V and FLEXOR DIGITI V both have their origins from the flexor retinaculum and insert into the base of the proximal phalanx.

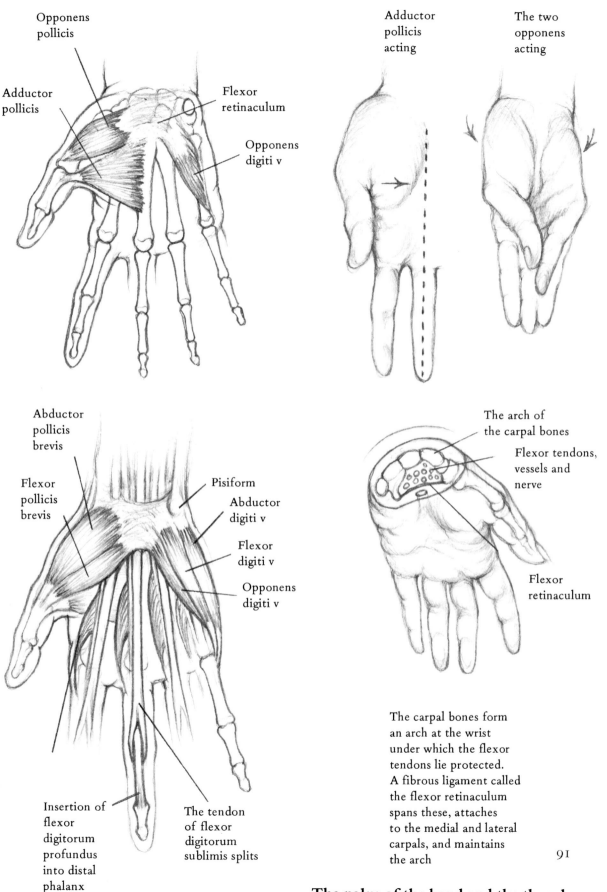

Opponens
pollicis

Adductor
pollicis

Flexor
retinaculum

Opponens
digiti v

Adductor
pollicis
acting

The two
opponens
acting

Abductor
pollicis
brevis

Flexor
pollicis
brevis

Pisiform

Abductor
digiti v

Flexor
digiti v

Opponens
digiti v

The arch of
the carpal bones

Flexor tendons,
vessels and
nerve

Flexor
retinaculum

Insertion of
flexor
digitorum
profundus
into distal
phalanx

The tendon
of flexor
digitorum
sublimis splits

The carpal bones form
an arch at the wrist
under which the flexor
tendons lie protected.
A fibrous ligament called
the flexor retinaculum
spans these, attaches
to the medial and lateral
carpals, and maintains
the arch

91

The palm of the hand and the thumb

The arm as a unit

Deltoid

Biceps

Brachialis

The
outcropping
thumb muscles

Brachioradialis

Triceps

92

Lateral
epicondyle

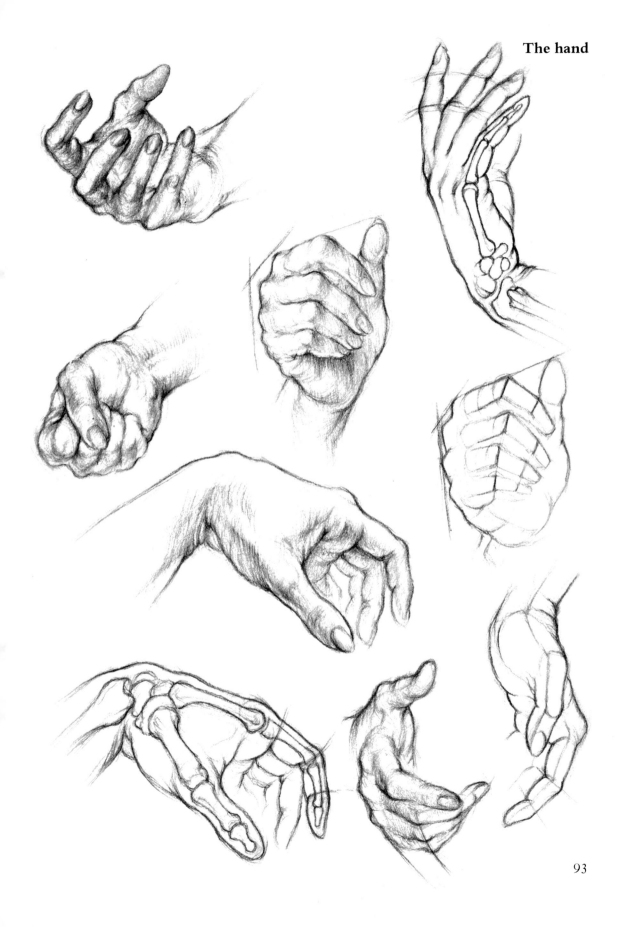

The thigh

The FEMUR is the longest bone in the body and articulates above with the pelvis and below with the tibia. Its upper end, the head, is two-thirds of a sphere. It fits into the deep socket of the pelvis called the acetabulum. This is a much more secure arrangement than at the shoulder joint where the bones don't fit as deeply together, but there is therefore less movement possible. The neck is placed obliquely and becomes continuous with the long shaft. In a child, the pelvis is narrow in width before it widens to take the bulk and weight of the abdominal viscera and bladder which gradually descend into it. The head, neck and shaft of the femur are almost in a straight line. This accounts for the tiny, narrow 'seat' and straight thighs in a young child. In the female, the pelvis is wider than the male, the acetabulum are further apart, and so the neck is at a sharper angle and the femurs run more obliquely.

At the junction of the neck with shaft are two outgrowths of bone called the greater and lesser trochanters. They are formed by the pull of tendons. The greater trochanter is almost subcutaneous and can be felt under the surface at the side of the hip.

The shaft is bowed forward and creates a thrust under the muscles at the front of the thigh.

The lower end of the femur is a heavy structure formed by the medial and lateral epicondyles and the medial and lateral condyles. The condyles are covered with cartilage and articulate with the top surface of the tibia. The lateral condyle is higher and has a sharp edge which can be felt at the side of the knee and can often be seen as a ridge when the knee is bent. The medial epicondyle and condyle create a large rounded form on the inner side of the knee which can also be felt and seen.

On the posterior aspect of the shaft (shown later) is a long roughened line called the linea aspera to which muscles of the thigh are attached.

The ILIOPSOAS is composed of two muscles, the iliacus which arises in a fan-shape from the inner curved surface of the ilium, and the psoas which is part of the iliacus that has migrated upward to arise from the sides of the bodies of the lumbar vertebrae and the discs between. The muscles pass under the inguinal ligament and insert by common tendon into the lesser trochanter. The femoral artery, vein and nerve which supply the front of the thigh lie in front of the muscle and behind the inguinal ligament as they enter the thigh. This creates a form called the femoral triangle, discussed later. The iliopsoas flexes the hip, pulling the femur up toward the body when the muscle shortens.

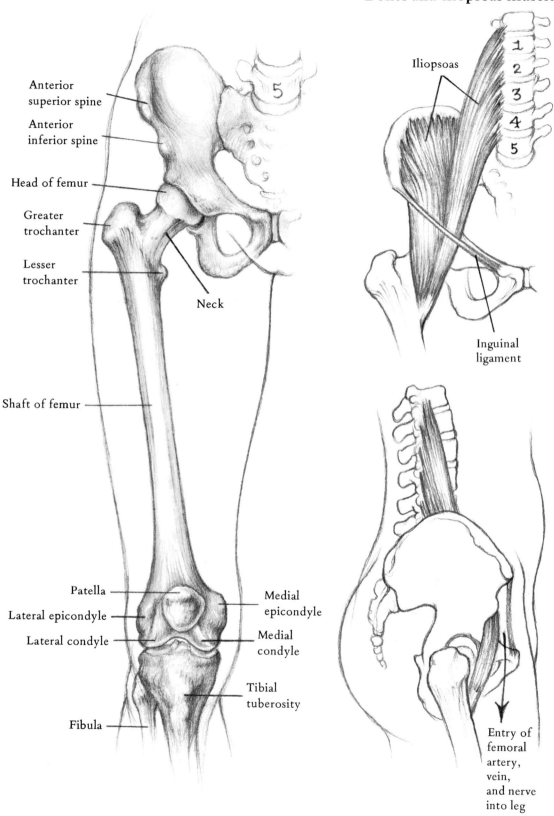

Bones and iliopsoas muscle

Anterior
superior spine

Anterior
inferior spine

Head of femur

Greater
trochanter

Lesser
trochanter

Neck

Shaft of femur

Patella

Lateral epicondyle

Lateral condyle

Medial
epicondyle

Medial
condyle

Tibial
tuberosity

Fibula

Iliopsoas

Inguinal
ligament

Entry of
femoral
artery,
vein,
and nerve
into leg

95

The adductors (Latin *adducere* – to bring or lead to)

The PECTINEUS arises from the front of the pubis, lateral to the pubic tubercle and is inserted into the back of the femur on a line leading from the lesser trochanter to the linea aspera. When the muscle contracts it draws the femur toward the midline of the body (adduction) and also can pull the femur up toward the trunk, flexing the hip.

The ADDUCTOR LONGUS arises from the front of the pubis close to the pubic symphysis, by a flat tendon. It expands into a triangular broad belly which is inserted by aponeurosis into the middle third of the linea aspera.

The ADDUCTOR BREVIS lies behind pectineus and adductor longus. It arises from the front of the pubis and the inferior ramus and is inserted into the upper part of the linea aspera.

The ADDUCTOR MAGNUS is a thick large triangular muscle situated on the medial side of the thigh. It arises from the inferior ramus of the pubis, the ramus of the ischium and the lateral part of the ischial tuberosity. The muscle is inserted into the length of the linea aspera and also by a tendinous cord into the medial epicondyle.

The last three adductors draw the femur toward the midline and can pull one thigh across the other. They assist in walking and running by pulling the femur forward as their origins on the pelvis lie on a plane in front of their insertions. They also flex the thigh by pulling the femur up toward the pelvis.

The GRACILIS is a thin muscle, broad above where it arises from the pubis and the length of the inferior ramus and a narrow tendon below where it is inserted into the upper part of the medial surface of the shaft of the tibia. It adducts the thigh and also flexes the knee.

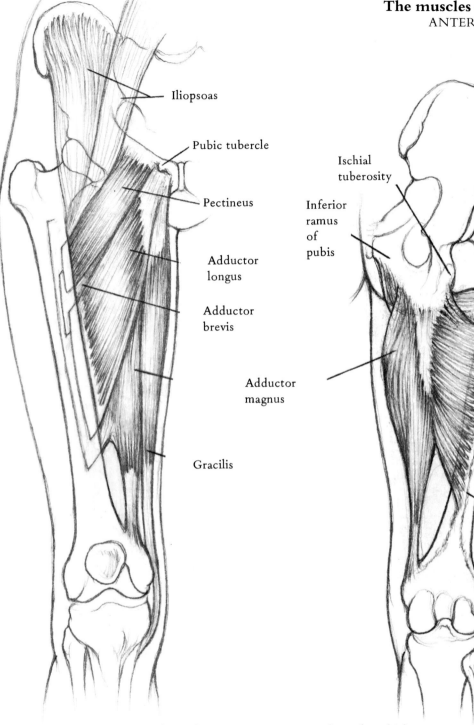

The muscles of the thigh
ANTERIOR ASPECT

Iliopsoas

Pubic tubercle

Pectineus

Adductor
longus

Adductor
brevis

Gracilis

Ischial
tuberosity

Inferior
ramus
of
pubis

Adductor
magnus

Linea
aspera

This is the ADDUCTOR group of muscles which
creates the large form on the inner part of
the thigh. They pull the femur toward the
midline and because they are attached to the
back of it, they can rotate the femur laterally
and draw one thigh across the other

97

Quadriceps femoris

The quadriceps femoris is composed of four muscles which insert by a common tendon into the tibial tuberosity. This common tendon rides against the lower end of the femur and the patella develops in it. The part of the tendon distal to the patella is called the patellar ligament.

The RECTUS FEMORIS has its origin from the anterior inferior spine of the pelvis and from a portion of the acetabular margin. It has a front tendon of origin and the muscle bundles which join to it are short and arranged in a bipennate manner. When they contract they create a bulging form on the front of the thigh. The precise flat taut shape of the tendon above the patella can often be seen. The knee is extended by this contraction and the pull on the patella. The muscle also is used to flex the hip, assisting the iliopsoas.

VASTUS LATERALIS and MEDIALIS arise by aponeurosis from the back of the femur along the linea aspera. Their insertions are continuous, vastus medialis inserting into two-thirds of the medial border of the patella and a small part of its base, and lateralis into the rest of the base and slightly into the lateral border. The muscles wrap around both sides of the thigh. Medialis is responsible for the full form at the medial side above the joint. Lateralis is responsible for the flatter form on the lateral side of the thigh.

VASTUS INTERMEDIUS has its origin from the front and lateral surfaces of the femur. It lies deep to the rectus femoris and adds to the rich curved form on the front of the thigh.

The three vasti act with rectus femoris to extend the knee as in walking and kicking, by pulling on the tibia. The medial and lateral vasti also act as stabilizers of the knee during movement.

When a tendon is subjected to exceptional wear and tear by the pressure and movement of the bone it overlies, it can develop within it a bone to withstand the stress. The patella is an example, and is called a sesamoid bone (a seed in the tendon). There are sesamoid bones in some thumb tendons, under the great toe in the short flexor tendons and at the wrist (the pisiform bone).

QUADRICEPS FEMORIS
Consists of four muscles
with a common insertion

Rectus femoris
Vastus lateralis
Vastus intermedius
Vastus medialis

Rectus
femoris

Adductor
magnus

Vastus
medialis

Vastus
lateralis

Base
of
patella

Rectus
femoris
removed
to show
vastus
intermedius

Insertion of quadriceps
femoris by common tendon
(patellar ligament)
into tibial tuberosity

Vastus medialis and
vastus lateralis wrap
around the femur and
are inserted along the
length of the back of the
femur

99

The muscles of the thigh
ANTERIOR ASPECT

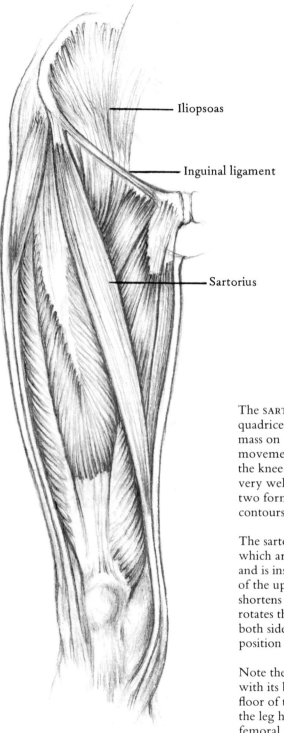

Iliopsoas

Inguinal ligament

Sartorius

The SARTORIUS MUSCLE creates a subtle division between the quadriceps femoris mass on the front of the thigh and the adductor mass on the medial aspect of the thigh. It is a long diagonal movement passing from the anterior superior spine to the inside of the knee. The form of the sartorius muscle itself is seen only on very well developed thighs with little fat covering. Note that the two forms which lie on either side of it have very different contours.

The sartorius is the longest muscle in the body, a narrow strap, which arises from the anterior superior spine and the bone below and is inserted by a long flattened tendon into the medial surface of the upper part of the shaft of the tibia. When it contracts and shortens (by about 15 cm 6 in.) it flexes the thigh at the pelvis, rotates the thigh laterally and flexes the knee. When the muscles of both sides are working the legs are brought into the 'cross-legged' position a tailor *sartor* used to assume at work.

Note the triangular form (rather recessed) at the top of the thigh with its base along the inguinal ligament. The iliopsoas makes the floor of this triangle and the femoral artery, vein and nerve enter the leg here from the trunk, lying on top of iliopsoas. This is the femoral triangle and a definite extra form to look for

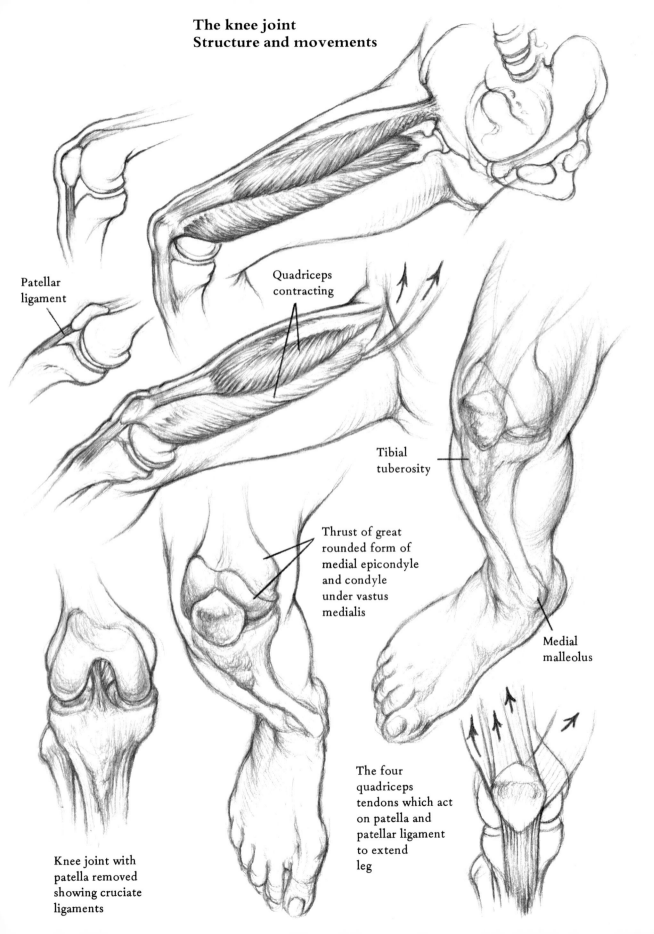

The knee joint
Structure and movements

Patellar
ligament

Quadriceps
contracting

Tibial
tuberosity

Thrust of great
rounded form of
medial epicondyle
and condyle
under vastus
medialis

Medial
malleolus

Knee joint with
patella removed
showing cruciate
ligaments

The four
quadriceps
tendons which act
on patella and
patellar ligament
to extend
leg

The knee joint

The bones are of prime importance in structuring the knee, and as certain portions of them are very close to the surface these can be used as landmarks. It is easier to see and study the structures on a flexed knee as the tendons and tissue around the joint are being pulled tightly over the bone. It is helpful to examine one's own knee in a mirror to look for the four principal forms one can see from the front. These are the medial and lateral condyles of the femur, the patella, and the rough triangular form below the patella caused by the attachment of the patellar tendon.

The MEDIAL and LATERAL CONDYLES of the femur rest on the medial and lateral condyles of the tibia. The medial epicondyle–condyle mass of the femur is responsible for a definite large rounded form on the inner side of the knee. The lateral side of the knee is flatter and the condyle has a sharp edge which creates a definite plane change. If the knee is thin, the front rounded forms of the femoral condyles can be seen.

The upper end of the tibia is a platform with two concave surfaces on which the femoral condyles rest. The surfaces are covered with cartilage and they have as well an extra semilunar pad of cartilage. The front of the upper end of the tibia has a triangular area of bone which has a bumpy surface because of the pull of the patellar ligament which inserts into it. From the lower apex of this triangle one can palpate on down the edge of the anterior border of the tibia (the shin) and feel the medial surface of the tibia which is just under the skin right down to the ankle (the medial malleolus).

The PATELLA is a triangular bone with its base at the top. Its back surface has facets with which it fits against the condyles of the femur. When one is standing, the patella is held loosely by its tendons and one can grasp the outer edges of it and move it. The upper surface of it creates a little form of its own, a definite plane change from its front surface. It is more of a wedge at the back, fitting into the trough between the condyles.

The skin over the region of the patella is loose and may appear as folds or wrinkles when the tendons attached to the patella are pulled taut during extension of the knee.

The knee joint
Structure and movements

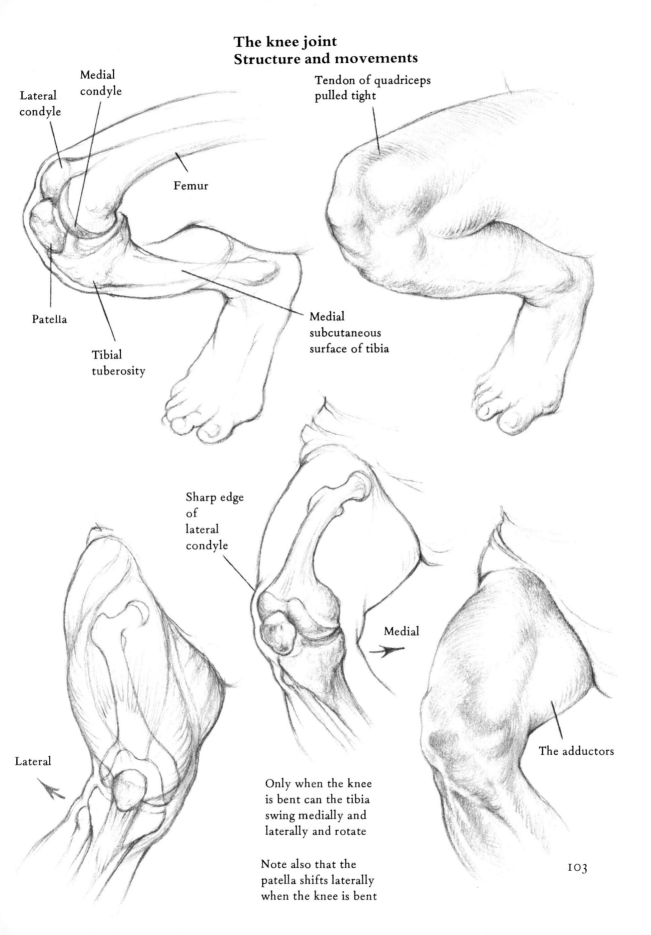

Lateral condyle

Medial condyle

Femur

Patella

Tibial tuberosity

Medial subcutaneous surface of tibia

Tendon of quadriceps pulled tight

Sharp edge of lateral condyle

Medial

Lateral

The adductors

Only when the knee is bent can the tibia swing medially and laterally and rotate

Note also that the patella shifts laterally when the knee is bent

The bones of the lower leg

There are two bones in the lower leg. The larger and stronger tibia is on the medial side and the slender and shorter fibula is on the lateral side.

The TIBIA is weight bearing and its upper end is greatly enlarged into two condyles to provide a surface for the body weight transmitted from the femur. The condyles of the femur articulate with two cupped surfaces on the medial and lateral condyles of the tibia. The most prominent feature of the upper end is the large triangular tibial tuberosity at the front into which the patellar ligament is inserted. The bone here becomes knobby and rough from the pull of the fibres and the form can be seen readily on the surface. The apex of the triangle leads onto the anterior border of the shaft of the tibia (the shin) which is subcutaneous.

The shaft of the tibia is triangular in cross-section having a posterior surface, and medial and lateral surfaces. The medial surface is also sub-cutaneous and can be seen and felt from the knee down to the enlargement of the bone at the ankle, the thick medial malleolus. The lower end articulates with the upper surface of the talus (trochlear surface) to make a hinge joint. Only two movements are possible here, swinging the foot up (dorsi-flexion) and swinging it down (plantar-flexion).

The FIBULA has a head at its upper end which articulates with the tibia, below and slightly to the back of the lateral condyle. The knob of the head can often be seen jutting out a little on the lateral side. The shaft is covered with muscle so it cannot be seen. The lower end of the shaft is enlarged and elongated into the lateral malleolus which projects to a lower level than the malleolus of the tibia. This point is worth noting as it is important for structuring the ankle region.

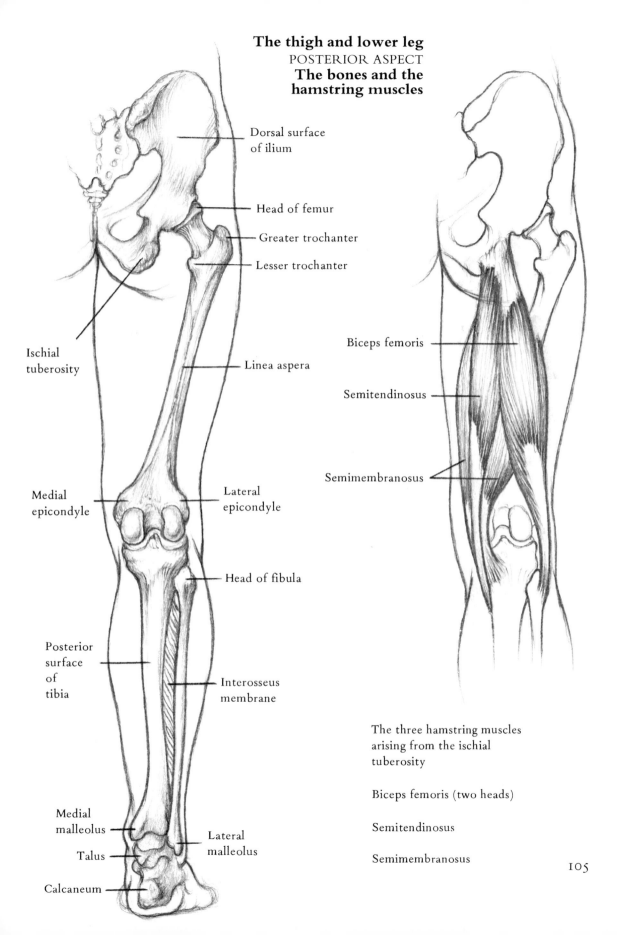

The thigh and lower leg
POSTERIOR ASPECT
The bones and the
hamstring muscles

Dorsal surface
of ilium

Head of femur

Greater trochanter

Lesser trochanter

Ischial
tuberosity

Linea aspera

Biceps femoris

Semitendinosus

Medial
epicondyle

Lateral
epicondyle

Semimembranosus

Head of fibula

Posterior
surface
of
tibia

Interosseus
membrane

The three hamstring muscles
arising from the ischial
tuberosity

Biceps femoris (two heads)

Medial
malleolus

Semitendinosus

Lateral
malleolus

Semimembranosus

Talus

Calcaneum

105

The hamstring muscles

These muscles are so named because if their tendons are cut behind the knee, the knee cannot be flexed to allow a step to be taken and a person is therefore powerless to move and is hamstrung.

There are three hamstring muscles, BICEPS FEMORIS which has two heads, SEMIMEMBRANOSUS and SEMITENDINOSUS. They have their origin from the ischial tuberosity of the pelvis, except for the shorter head of the biceps which arises from the shaft of the femur. Their bellies account for the rich rounded form at the back of the thigh.

The two heads of biceps femoris are inserted into the head of the fibula by a common tendon. Semimembranosus is inserted by a thick tendon into the medial condyle of the tibia. Semitendinosus has a longer tendon which passes from behind the knee, forward, to insert into the medial surface of the tibia. These tendons can be felt on either side of the back of the knee when it is flexed and they account for the medial and lateral 'pillar' forms one sees at the back of the knee joint.

The three gluteal muscles

Gluteus minimus arises from the lower part of the dorsal surface of the ilium and is inserted into the greater trochanter

Iliac crest

Both of these muscles can lift the femur sideways (abduct the hip) and also rotate the femur forward (medially)

Gluteus medius arises from the upper free area of the dorsal surface of the ilium and is inserted into the greater trochanter

Gluteus maximus

Ilio-tibial tract

Gluteus medius creates a very definite rounded form at the upper and lateral side of the hip, particularly when it is contracting. Where the muscles become tendinous toward their insertion there is a hollow in the hip above the outward thrust of the greater trochanter

107

The gluteal region

The gluteus maximus, the tensor fasciae lata and the ilio-tibial tract

The TENSOR FASCIAE LATAE is a small muscle about 15 cm (6 in.) long which is attached to the anterior superior spine and adjacent iliac crest. It is inserted into the ilio-tibial tract.

The ILIO-TIBIAL TRACT is a part of the whole sheath of fascia which encloses the muscles of the thigh. Fascia is a sheet of fibrous tissue enveloping the body beneath the skin. That of the thigh is particularly strong and is called fascia lata. The fibres of the sheath run circularly but at the lateral side of the thigh there is a very strong band of fibres running longitudinally between the circular layers of the sheath. This band is called the ilio-tibial tract. This tract is an important structure to understand in drawing the thigh because it not only creates a taut band down the side of the thigh but there is a long furrow created at its posterior border. This is because the tract is attached along its length to the lateral intermuscular septum, a wall of fascia which divides the hamstrings from the quadriceps. This wall or partition is in turn attached along the length of the linea aspera of the femur. The long furrow between the two great muscles masses is apparent to varying degrees on most thighs. It is well back on the lateral side. Tensor fasciae latae muscle through its insertion can tighten the fascia lata and assist in extending the knee. It helps to stabilize the pelvis on the head of the femur. It is especially well developed in ballet dancers, as are the gluteus minimus and medius, where the full range of hip movements are used so constantly. It is an abductor also along with these two gluteal muscles.

GLUTEUS MAXIMUS is the very large rhomboidal-shaped muscle of the hip. It has its origins from the posterior part of the iliac crest, the posterior superior spine, the side and back of the sacrum and the ligaments and aponeuroses in that area, and the coccyx. The lower border runs from the coccyx to about one third of the way down the femur. Its upper border is parallel to the lower one. The inner lower quarter of the muscle has a direct insertion into the bone of the femur. The remaining three-quarters is inserted into the ilio-tibial tract. Through this attachment the gluteus maximus becomes the powerful extensor of the knee, because the tract is attached to the lateral condyle of the tibia in front of the axis of the knee joint. It is used in climbing and in running.

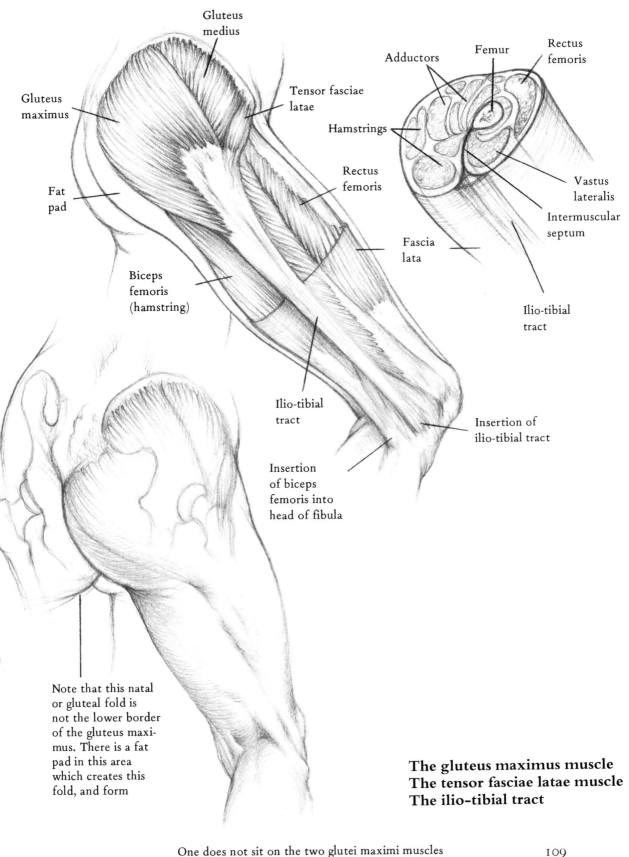

Gluteus medius

Gluteus maximus

Fat pad

Tensor fasciae latae

Rectus femoris

Biceps femoris (hamstring)

Ilio-tibial tract

Insertion of biceps femoris into head of fibula

Adductors

Femur

Rectus femoris

Hamstrings

Vastus lateralis

Intermuscular septum

Fascia lata

Ilio-tibial tract

Insertion of ilio-tibial tract

Note that this natal or gluteal fold is not the lower border of the gluteus maximus. There is a fat pad in this area which creates this fold, and form

The gluteus maximus muscle
The tensor fasciae latae muscle
The ilio-tibial tract

One does not sit on the two glutei maximi muscles but on the ischial tuberosities which are protected by dense fibrous tissue, by a cushion of fluid in a sac called a bursa, and by the fat pad and skin

The muscles of the lower leg – anterior aspect

There are no muscles arising from the medial surface of the tibia which is subcutaneous, though the forms of the posterior muscles soleus and gastrocnemius can be seen on the medial side of the leg.

The anterior muscles

Four muscles arise from the lateral surface of the tibia, the interosseus membrane and the fibula, whose tendons pass to the dorsum of the foot.

TIBIALIS ANTERIOR arises from the lateral condyle of the tibia, the upper two-thirds of the lateral surface of the tibia and the interosseus membrane. Its muscle bundles create a very rich form on the front of the leg in this area. Its tendon passes obliquely and is inserted into the first cuneiform and the first metatarsal on their medial sides. The strong tendon can be seen frequently as it crosses medially to its insertion, and is a landmark in the area. The muscle maintains the longitudinal arch of the foot and acts as a dorsiflexor of the foot.

EXTENSOR DIGITORUM LONGUS arises from the lateral condyle of the tibia, the interosseus membrane and the upper three-quarters of the anterior surface of the shaft of the fibula. It adds to the great curved form toward the lateral side of the leg. Its tendon passes beneath the retinaculum of the ankle, as do all the tendons entering the dorsum of the foot, and then divides into four. These tendons run forward on the dorsum of the foot and can be seen here before they insert in the second, third, fourth and fifth toes. Their insertion is by an expansion like the extensor digitorum of the hand. The tendons are joined by those of extensor digitorum brevis, which arises in the foot. These two muscles extend the toes and with continuing action, dorsiflex the foot. If you put your hand on the upper part of your leg and then pull your toes up you can feel the bulge under your hand where the cells are contracting and also see the tendons of extensor digitorum and tibialis anterior clearly, in the foot.

EXTENSOR HALLUCIS LONGUS lies partially hidden by the first two muscles. It arises from the middle half of the fibula and the interosseus membrane. Its strong tendon passes obliquely to the great toe. When you pull the great toe up (extend it) the tendon stands out clearly. It is an important structure for the artist to note as there is a plane change in the foot along the length of the tendon.

PERONEUS TERTIUS is a part of extensor digitorum longus and arises from the lower one-third of the anterior surface of the fibula. Its tendon passes to insert into the upper part of the base of the fifth metatarsal and often

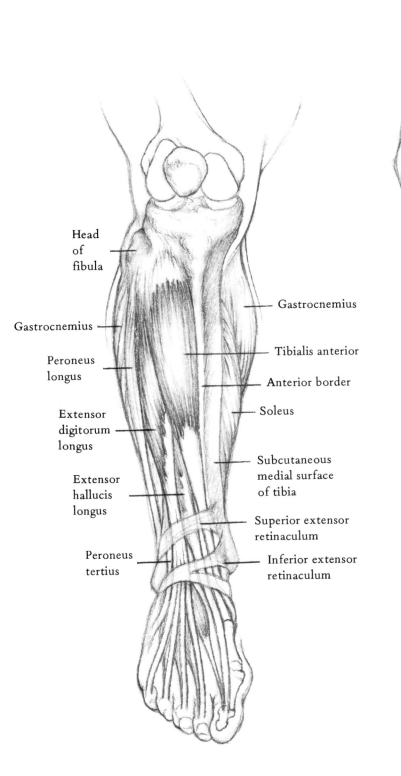

Head
of
fibula

Gastrocnemius

Peroneus
longus

Extensor
digitorum
longus

Extensor
hallucis
longus

Peroneus
tertius

Gastrocnemius

Tibialis anterior

Anterior border

Soleus

Subcutaneous
medial surface
of tibia

Superior extensor
retinaculum

Inferior extensor
retinaculum

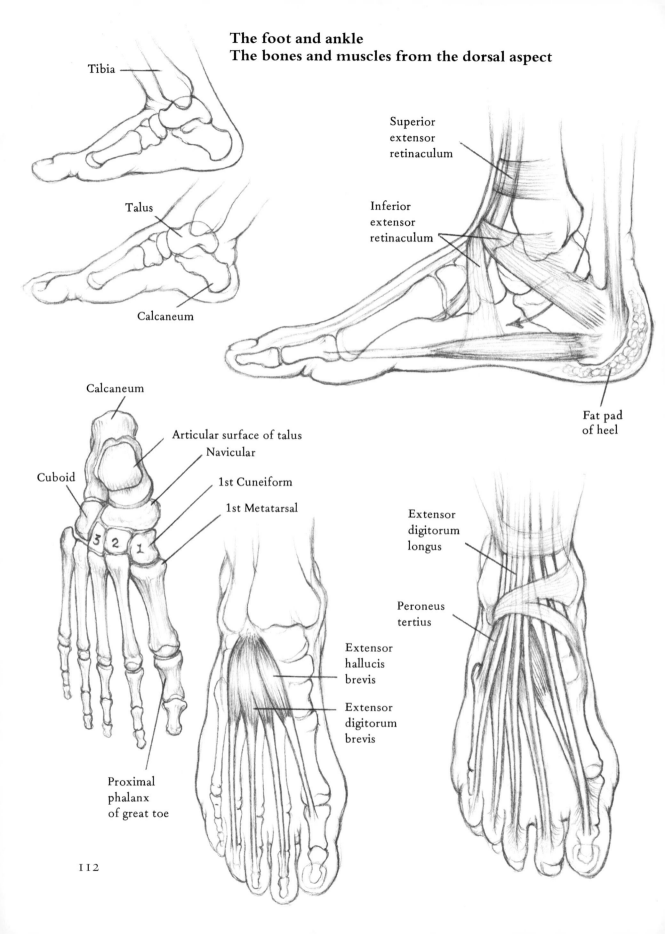

The foot and ankle
The bones and muscles from the dorsal aspect

Tibia

Talus

Calcaneum

Superior
extensor
retinaculum

Inferior
extensor
retinaculum

Fat pad
of heel

Calcaneum

Articular surface of talus

Navicular

Cuboid

1st Cuneiform

1st Metatarsal

3 2 1

Extensor
digitorum
longus

Peroneus
tertius

Extensor
hallucis
brevis

Extensor
digitorum
brevis

Proximal
phalanx
of great toe

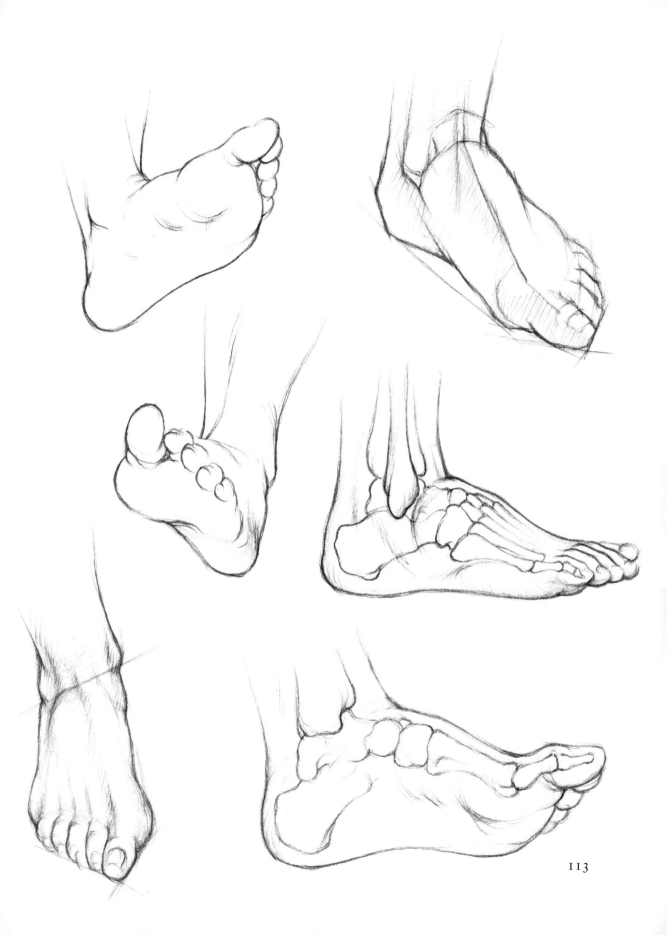

spreads out along the bone. It is not always present. Its action is to not only dorsiflex the foot but to raise the lateral side of the foot so man can walk four-square.

PERONEUS LONGUS arises from the head of the fibula and the upper two-thirds of its lateral surface. Its long tendon runs obliquely backward to pass behind the lateral malleolus before entering the foot. It then crosses the sole of the foot to insert into the first metatarsal and the cuneiforms. It is an evertor of the foot, pulling up the lateral side of it, and also maintains the transverse and longitudinal arches of the foot.

PERONEUS BREVIS arises from the lower two-thirds of the lateral surface of the fibula. Its tendon also passes behind the lateral malleolus and then goes forward to insert into the base of the fifth metatarsal. The muscle works to keep the foot steady and level.

EXTENSOR HALLUCIS BREVIS and EXTENSOR DIGITORUM BREVIS arise from the upper front part of the calcaneum. Their muscle bellies create a fat little form on the dorsum of the foot.

The EXTENSOR RETINACULUM is strong fibrous fascia which has developed into bands at the ankle. There is both a superior and inferior band which bind down the tendons and keep them from bowstringing forward and also medially. They create a certain plane of tension at the front of the ankle which is important in interpreting this area. The retinaculum is anchored very firmly on each side as it blends with the bone of the tibia, fibula and calcaneum. Note also when drawing the ankle from the side that the distance from where the inferior retinaculum binds down the tendons at the front, diagonally across to the back of the heel, is a long span to be accounted for. The tendons coming from the back of the leg into the foot also pass beneath the band.

The foot and lower leg

The forms to look for are the gastrocnemius and the long straight form of the achilles tendon inserting into the calcaneum, the diagonal movement of peroneus longus and brevis as their tendons pass behind the lateral malleolus of the fibula, and the bulk of extensor digitorum longus and the tibialis anterior at the front of the leg. Note that the mass of muscle bundles which can contract are well up in the leg, and that the leg tapers as the muscles become tendinous

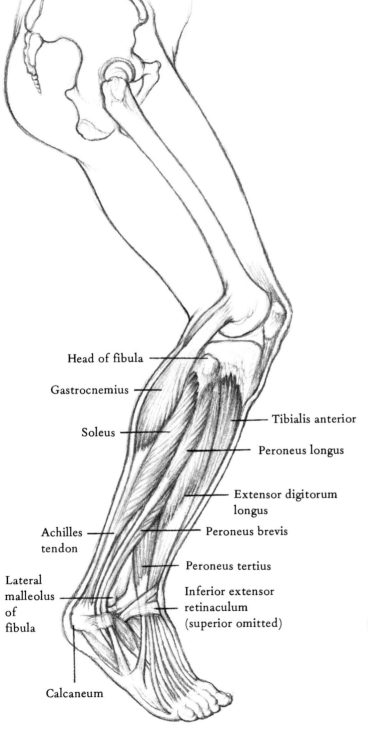

Head of fibula

Gastrocnemius

Soleus

Tibialis anterior

Peroneus longus

Extensor digitorum longus

Achilles tendon

Peroneus brevis

Peroneus tertius

Lateral malleolus of fibula

Inferior extensor retinaculum (superior omitted)

Calcaneum

The muscles of the lower leg – posterior aspect

There are three deep muscles on the back of the leg whose tendons pass behind the tibia and then pass forward and downward into the foot. They are all bipennate muscles.

TIBIALIS POSTERIOR arises from the lateral part of the posterior surface of the tibia, from the interosseus membrane and from the upper part of the posterior surface of the fibula. Its tendon passes behind the medial malleolus in a groove in the bone and then passes downward and forward to insert into the navicular bone and sends fibrous slips to the three cuneiform bones and the bases of the centre three metatarsals.

The tibialis posterior is the main invertor of the foot. The fibrous slips which attach on the plantar surface (the sole) of the cuneiforms and metatarsals support the longitudinal arch of the foot when it is weight bearing.

FLEXOR HALLUCIS LONGUS arises from the lower two-thirds of the shaft of the fibula and the lower part of the interosseus membrane. Its tendon lies in a groove on the posterior surface of the lower end of the tibia, a groove on the talus and passes under a small bony projection of the calcaneum on its medial side before entering the foot. The tendon runs forward in the sole and inserts into the base of the distal phalanx of the great toe. When the foot is off the ground this muscle flexes the great toe. When the foot is on the ground, it helps keep the pad of the great toe gripped to the ground, in co-operation with flexor hallucis brevis.

FLEXOR DIGITORUM LONGUS arises from the posterior surface of the tibia and also the fascia covering tibialis posterior. It has a long tendon which passes behind the medial malleolus and crosses below the tendon of flexor hallucis longus. In the foot the tendon is joined by the flexor digitorum accessorius and then it divides into four tendons which insert into the distal phalanges of the second, third, fourth and fifth toes. The muscle bundles contracting on the back of the leg flex the ends of the toes when the foot is off the ground. When the foot is on the ground it holds the pads of the toes to the ground with the help of smaller muscles in the foot.

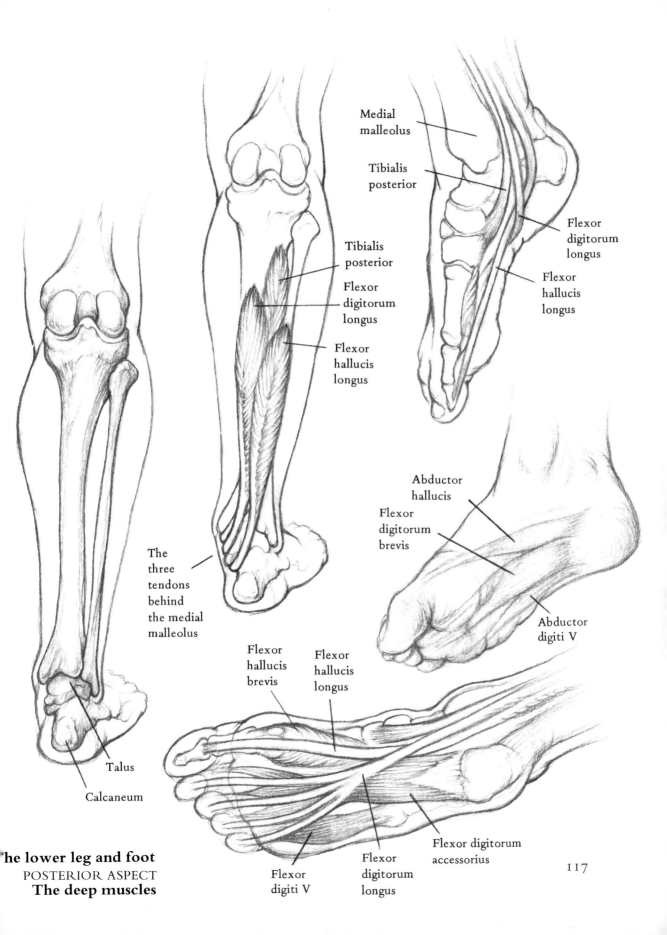

Medial
malleolus

Tibialis
posterior

Flexor
digitorum
longus

Flexor
hallucis
longus

Tibialis
posterior

Flexor
digitorum
longus

Flexor
hallucis
longus

Abductor
hallucis

Flexor
digitorum
brevis

Abductor
digiti V

The
three
tendons
behind
the medial
malleolus

Talus

Calcaneum

Flexor
hallucis
brevis

Flexor
hallucis
longus

Flexor
digiti V

Flexor
digitorum
longus

Flexor digitorum
accessorius

The lower leg and foot
POSTERIOR ASPECT
The deep muscles

117

The POPLITEUS arises by a strong tendon from the lateral epicondyle of the femur. It crosses behind the upper end of the tibia and is inserted by a wide base into the posterior surface of the tibia above the origin of the soleus muscle. When the knee is flexed, the popliteus initiates the rotation movements of the lower leg.

The SOLEUS is a large flat muscle with a horse-shoe shaped origin from the upper one-fourth and head of the fibula, from a fibrous band which stretches between the fibula and tibia and from the middle one-third of the medial border of the tibia. The muscle bundles are short and end in a large tendon which joins that of the gastrocnemius to form the achilles tendon. This muscle creates some of the bulk in the upper part of the back of the leg. The lateral portion of it creates a full form on the side of the leg which should not be missed as this differentiates the contour of the lateral side from the medial side.

The PLANTARIS is a tiny muscle with a very long tendon. It arises above the lateral epicondyle of the femur. The tendon runs to the medial side of the achilles tendon after passing between the soleus and gastrocemius. In the foot a part of it becomes the plantar aponeurosis beneath the skin of the sole and acts as a tie for the longitudinal arch of the foot.

The GASTROCNEMIUS is the large superficial muscle of the back of the lower leg which is responsible for the principal form that is seen. It has two heads attached above the condyles of the femur by strong flat tendons. The two fleshy bellies end in a large flat tendon at the middle of the leg which blends with that of the soleus to form the achilles tendon. The tendon creates a straight, taut feeling from its insertion into the calcaneum to where it meets the muscle bundles. The upper tendons of the heads can often be seen as indented forms as the working bundles contract and bulge around them. At the middle of the leg there is often a very definite demarcation between the bulge of the muscle bundles and the tendon. The furrow between the two bellies is also apparent on some legs.

The soleus and gastrocnemius are the chief plantar flexors of the foot by their pull on the calcaneum. They are the propulsive force in walking and jumping and the soleus has a stabilizing effect with the balance of the leg on the foot when one is standing.

The lower leg
POSTERIOR ASPECT
The superficial muscles

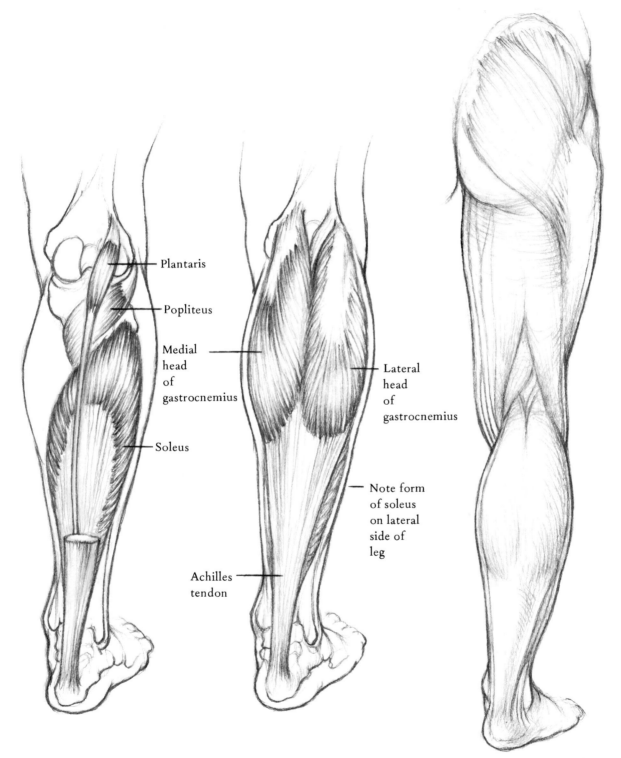

Plantaris

Popliteus

Medial
head
of
gastrocnemius

Soleus

Lateral
head
of
gastrocnemius

Note form
of soleus
on lateral
side of
leg

Achilles
tendon

The lower leg
MEDIAL ASPECT

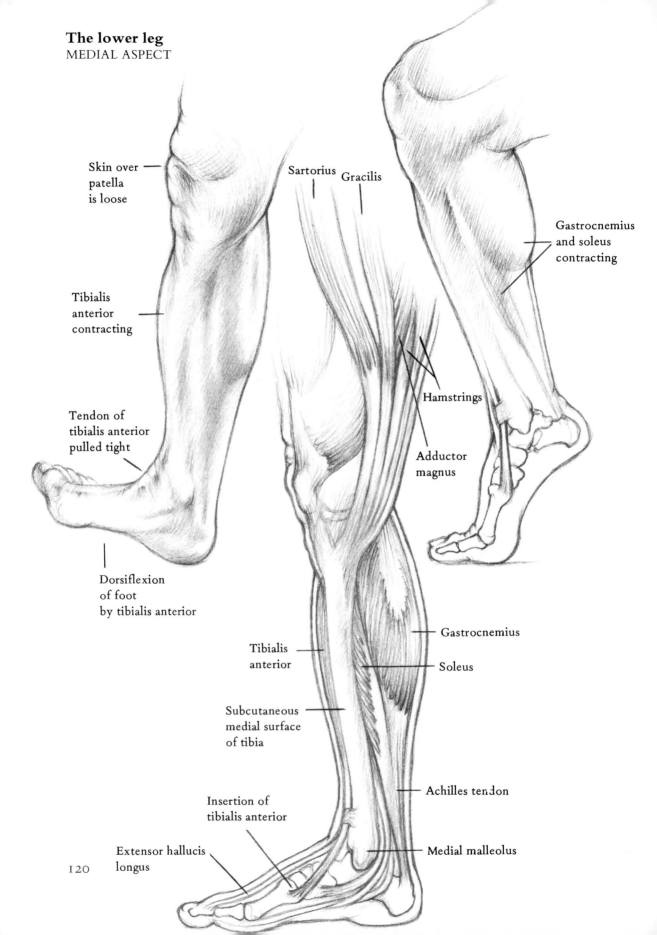

Skin over patella is loose

Tibialis anterior contracting

Tendon of tibialis anterior pulled tight

Dorsiflexion of foot by tibialis anterior

Sartorius

Gracilis

Hamstrings

Adductor magnus

Gastrocnemius and soleus contracting

Gastrocnemius

Soleus

Tibialis anterior

Subcutaneous medial surface of tibia

Insertion of tibialis anterior

Extensor hallucis longus

Achilles tendon

Medial malleolus

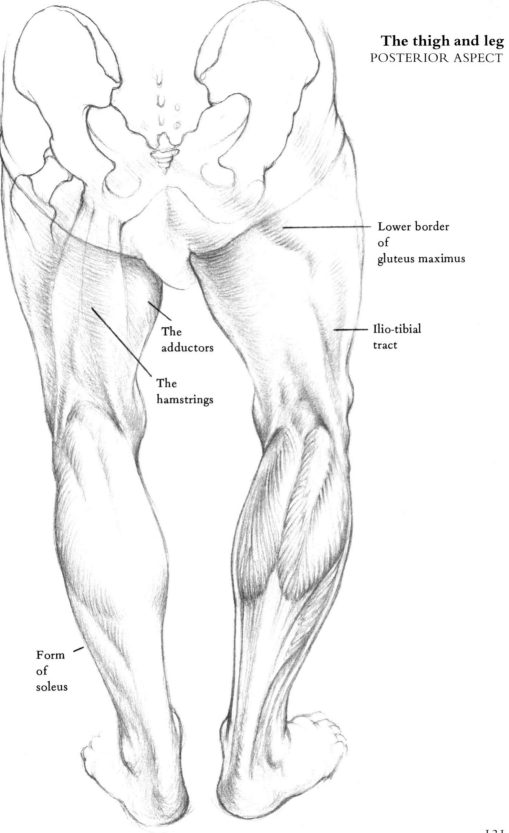

The thigh and leg
POSTERIOR ASPECT

Lower border
of
gluteus maximus

Ilio-tibial
tract

The
adductors

The
hamstrings

Form
of
soleus

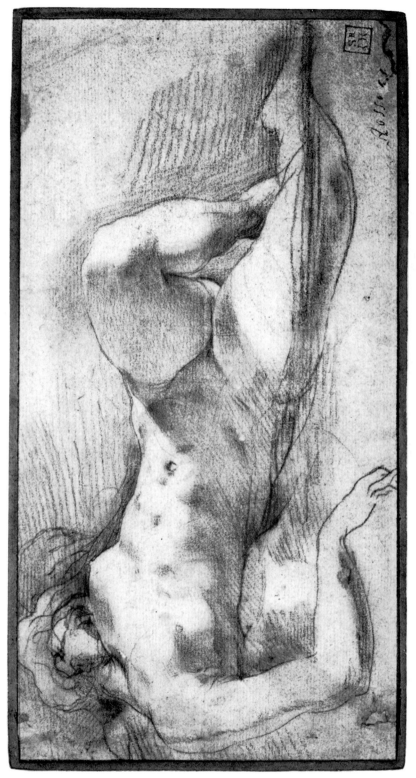

Study for a Nude by Rosso Fiorentino
British Museum, London

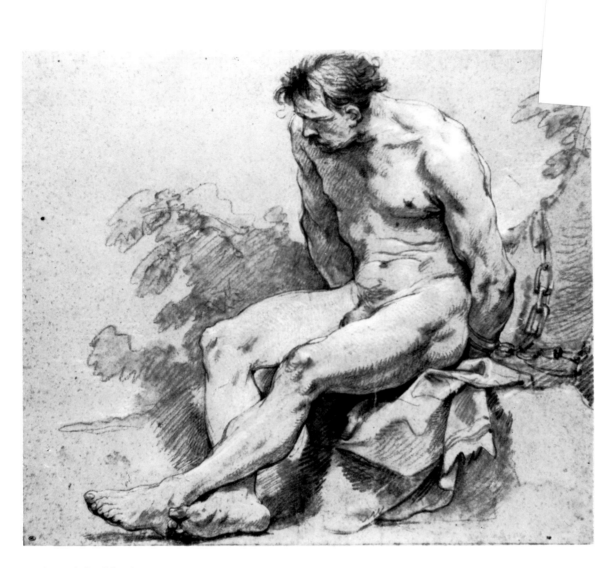

Nude Study by Natoire
The Louvre, Paris

Perspective and measurements

Two methods of taking measurements

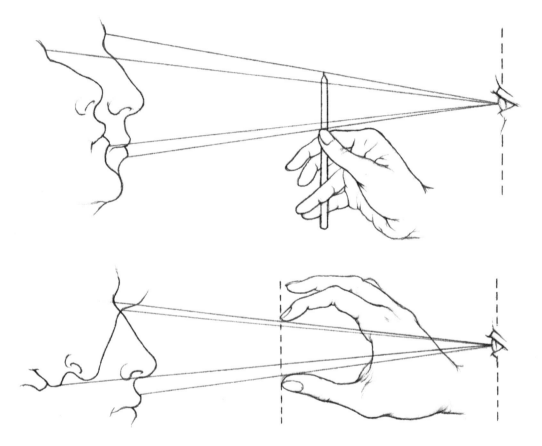

1 Your arm is held out directly in front of you with the elbow kept stiff.
2 The pencil, or the imaginery line of the 'claw' between the thumb and index finger, is kept parallel to (in the same plane as) your own face and eyes.

Note The 'claw' method of measuring is included and you may find it quicker than using the long pencil for measuring and then changing to a short pencil for drawing. One has to be careful though that the imaginery line between the thumb and the index finger is kept parallel to the face for every measurement and that the arm is kept stiff. This 'claw' method is also useful for you to make quick relative measurements on your drawing page. It is perhaps not as exact a method as the pencil method which is taught in most art colleges.

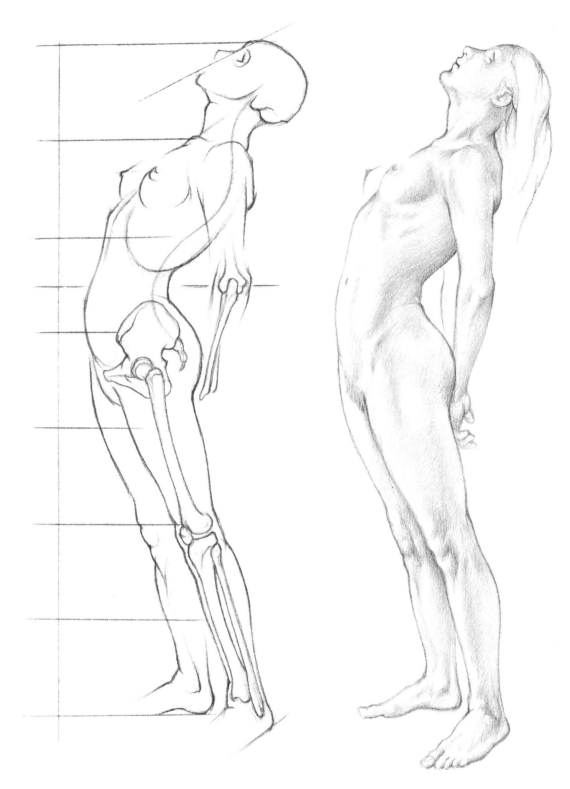

All of the straight structuring lines for measuring and assessing movement shown as dark here are usually put in very lightly. Often only a light tick on the paper is needed as a guide

The basic measurement used here is the distance between the suprasternal notch and the top of the head. The bony landmarks which are indicated include the skull and the angle of the face, the suprasternal notch area and the top of the shoulder, the form of the rib cage and the angle of it, the scapula, the elbow joint, the anterior superior spine of the pelvis, the knee joints and ankle joints

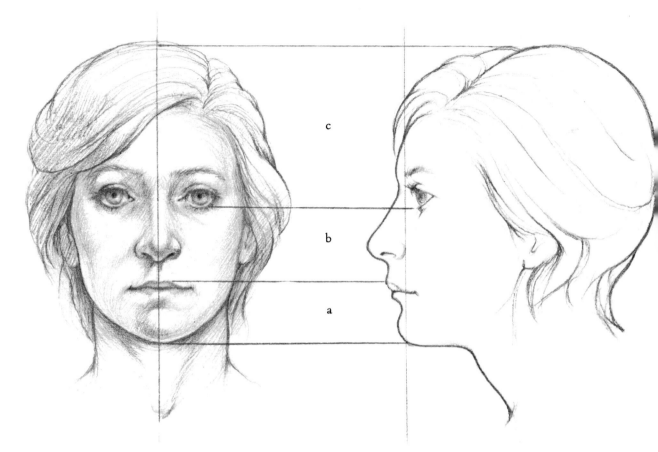

This shows the front view of the face with the side projection,
when the face is in the same plane as (parallel to) your own face
and eyes. The vertical distances between certain points are marked
(a), (b) and (c)

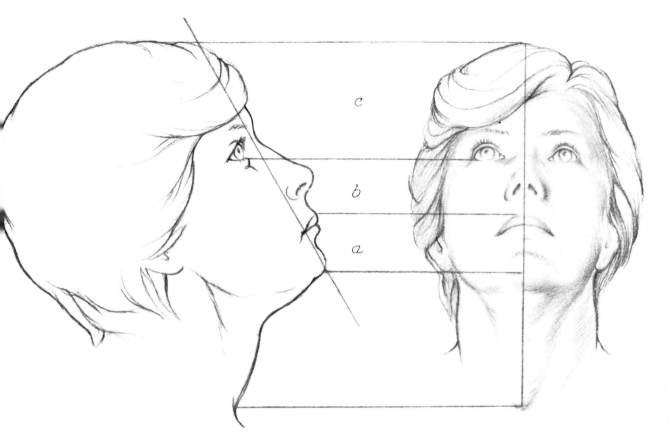

This shows the front view of the face with the side projection, when the face is turning back from the vertical plane of your own face and eyes. Compare with the previous illustration. The vertical distance (a), is almost the same, because the turning back is slight here. The distance designated (b), has diminished relatively more, and the vertical distance designated by (c), has diminished the greatest. This is because the parts of the face in the (b) and (c) areas are moving further and further away from the vertical plane of your own face and eyes

With the body bent sideways and
forward, this figure is about five
heads in length. The measurement
for the position of the pubic
symphysis (two heads down and
two heads in from the vertical)
enables you to place the curve of
the movement

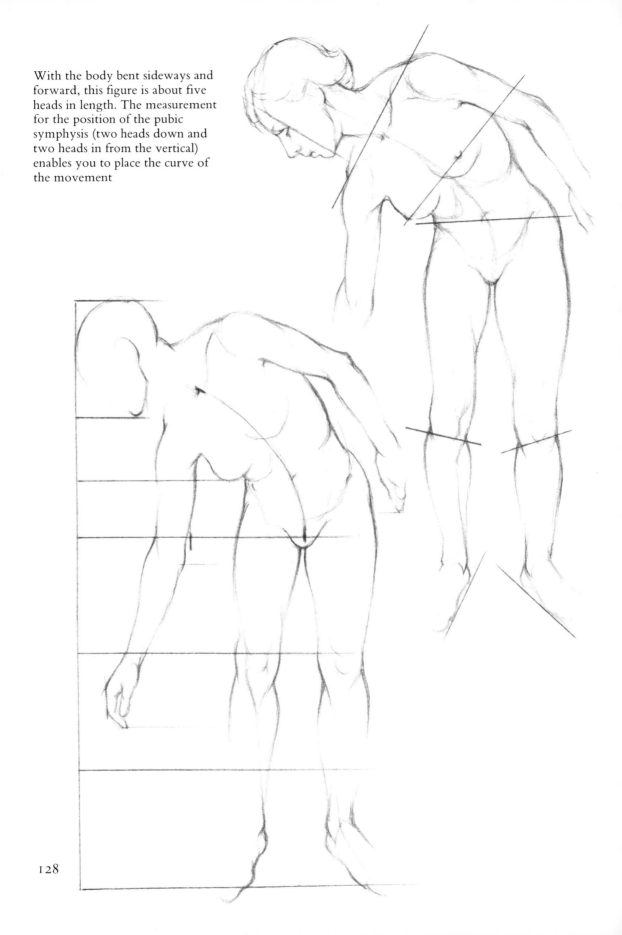

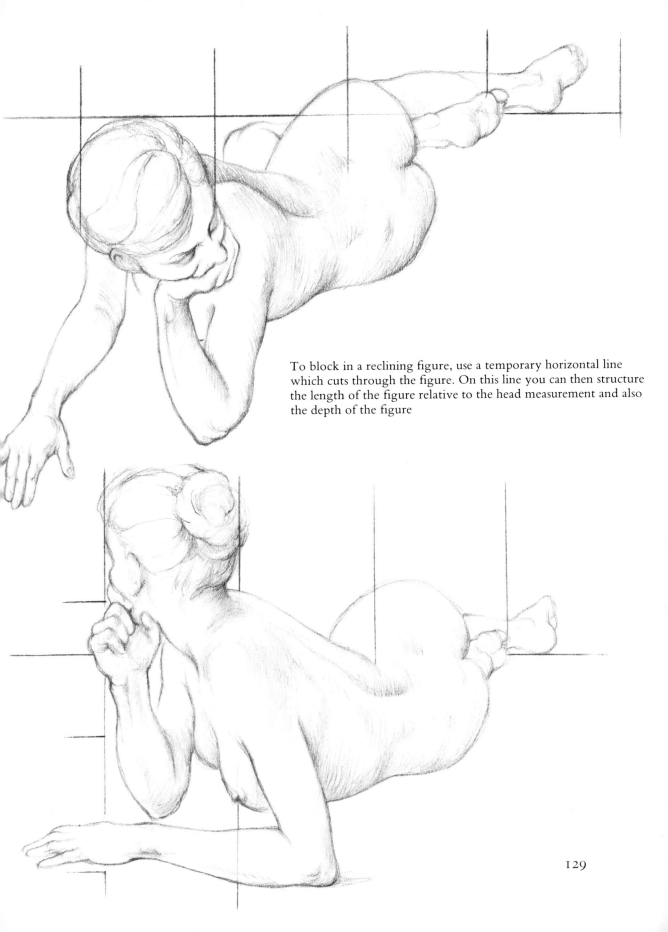

To block in a reclining figure, use a temporary horizontal line which cuts through the figure. On this line you can then structure the length of the figure relative to the head measurement and also the depth of the figure

129

The basic measurement used here is the distance between the chin
and the hair-line. The rest of the figure is structured relative to this.
Remember all of these measurements are taken in the same place
as your eyes and face, the pencil or the imaginary line of the
'claw' being held at arm's length parallel to your face

When the arms or legs are in perspective, use the distance between two of the overlapping forms as a measurement guide

One minute sketch of great vitality.
Brown conte on cartridge
by Ian Lawrence, Toronto, Canada

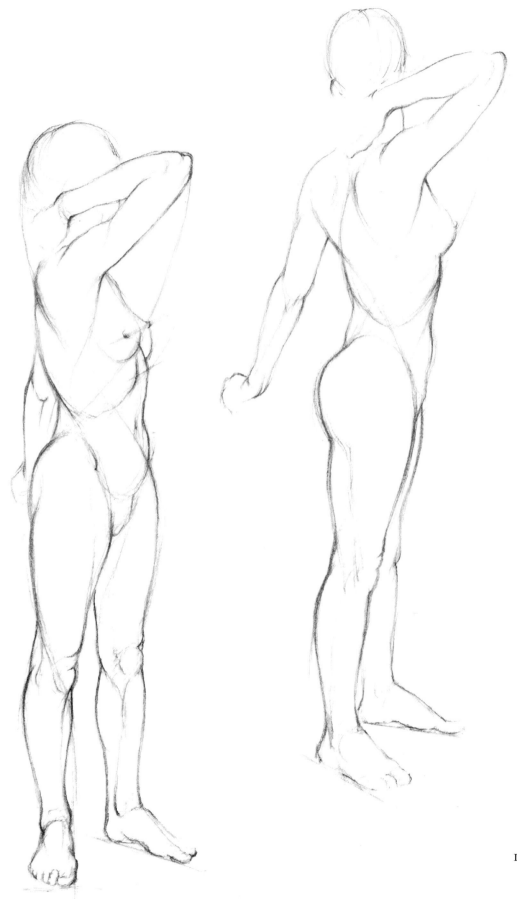

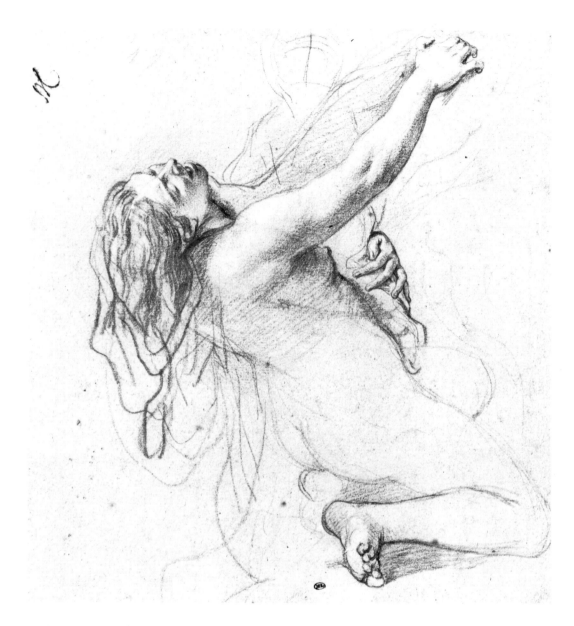

Nude Woman Kneeling
and Holding Baby by Charles Le Brun
Red chalk with white lead highlights on beige paper
The Louvre, Paris

Detail on facing page

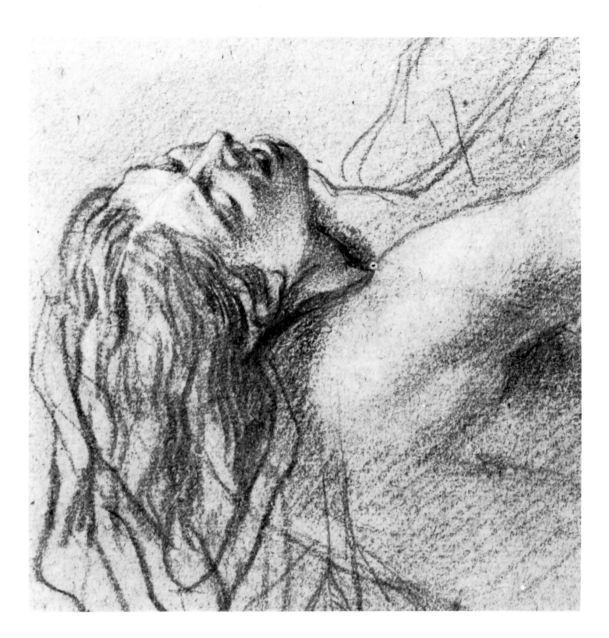

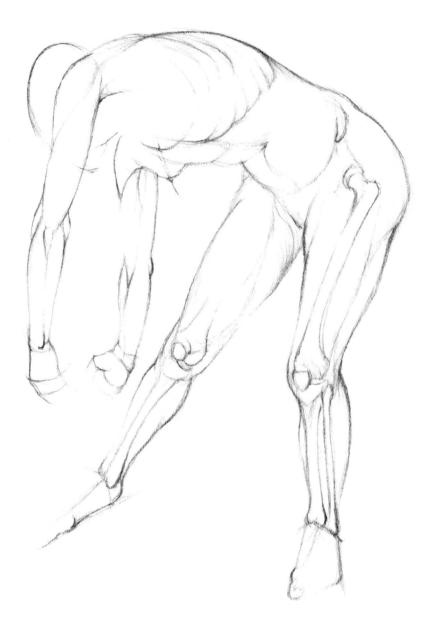

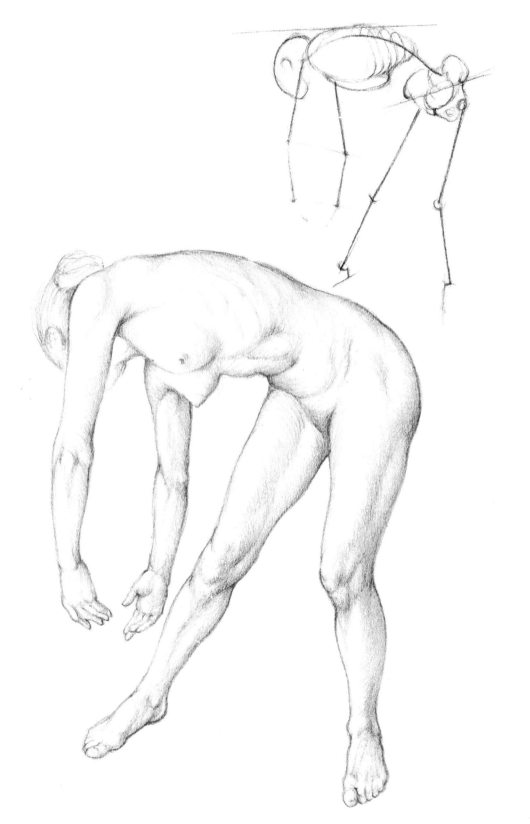

137

Glossary

Abduction	Movement away from the central axis of the body
Adduction	Movement towards the central axis of the body, or beyond it
Anterior	Towards the front or ventral side
Aponeurosis	A tendon in a sheet-like form to allow for wider attachment
Articulate	To make a joint so motion is possible between two parts
Axilla	Armpit
Cervical	Pertaining to the neck
Clavicle	Collar-bone
Cranium	The part of the skull enclosing the brain
Digitations	Finger-like processes
Depressor	A muscle which lowers
Extensor	A muscle whose contraction straightens or extends a joint
Fascia	A sheet of fibrous tissue covering the body under the skin and also providing sheaths for muscles
Form	The visible three-dimensional aspect
Flexor	A muscle whose contraction bends a joint to bring closer the two parts which it connects
Inferior	Below
Insertion	The muscle attachment to a movable point
Labii	Lips
Lateral	Towards the outer side
Levator	A muscle which lifts
Medial	Towards the midline (axial line)
Origin	The stationary point of a muscle attachment
Plane	A flat surface
Posterior	At the back, behind
Pronate	To rotate the forearm so the palm looks backwards
Scapula	Shoulder-blade
Shape	The outline and external surface
Supinate	To turn the forearm and hand palm side forwards

Quick sketch on textured paper. Charcoal and blue watercolour

Suppliers

Great Britain

L Cornelissen and Son
Great Russell Street
London WC1B 3RY

Daler Rowney
PO Box 10
Bracknell
Berkshire RG12 8ST

Collart Fine Art
Whitefriars Avenue
Wealdstone
Harrow
MIDDX HA3 5RH

Artworks
28 Spruce Drive
Paddock Wood
Lightwater
Surrey GU18 5YX

Broad Canvas
20 Broad Street
Oxford OX1 3AS

Doodles
61 High Street
Newport Pagnell
Bucks MK16 8AT

Alexanders Art Shop
58 South Clerk Street
Edinburgh EH8 9PS

Frank Herring and Sons
27 High West Street
Dorchester
Dorset

Forget-Me-Not
70 Upper James Street
Newport
Isle of Wight PO30 1LQ

Paper specialists

Falkiner Fine Papers Ltd
76 Southampton Row
Holborn WC1B 4AR

USA

Arthur Brown
2 West 46 Street
New York

The Morilla Company Inc
43 21st Street
Long Island City
New York
and 2866 West 7 Street
Los Angeles
California

Stafford-Reeves Inc
626 Greenwich Street
New York, NY 08701

Winsor and Newton Inc
PO Box 1396
Piscataway
New Jersey 08855

Paper specialists

Hobart Paper Co
11 West Washington Street
Chicago, Illinois 60600

Wellman Paper Co
308 West Broadway
New York, NY 10012